bella donna

bella donna

a renaissance mystery novel

Barbara Cherne

2001 · FITHIAN PRESS, SANTA BARBARA, CALIFORNIA

Published by Fithian Press
A division of Daniel and Daniel, Publishers, Inc.
Post Office Box 1525
Santa Barbara, CA 93102
www.danielpublishing.com

LIBRARY OF CONGRESS CATALOGING–IN–PUBLICATION DATA
Chrene, Barbara, (date)
 Bella donna : a Renaissance mystery novel / by Barbara Cherne.
 p. cm.
 ISBN 1-56474-362-4 (pbk : alk. paper)
 1. Florence (Italy)—History—1421–1737—Fiction. 2. Women cooks—
Fiction. 3. Artists—Fiction. I. Title
 PS3553.H3547 B45 2001
813'.54—dc21 00-010244

To Henry and Ingrid

bella donna

one

THE DAY OF THE FATEFUL QUARREL BEGAN with heat so scorching that even within the vaulted walls of the palazzo kitchen no relief was to be found. Giuditta, the cook, having taken the hot bread out of the brick oven, could not decide whether to leave the windows and the door to the garden open or closed this morning. This summer, the heat had been exceptionally severe, even for Florence, and many of the *signori* who had villas in the country had already left.

Her employers, the Novella family, still remained, although the last time the heat had been so fierce—was it only two years ago, in '94, when the Medici fled the city?—they had removed themselves to their villa early in June. She looked forward to staying at the villa in the summer; aside from the coolness and freshness of its air, the country evoked memories of her childhood on a small farm north of the city.

A shiny crescent of light smiled at her from the glazed white depths of the mixing bowl as she broke the first egg into it. This evening, the *signori* would dine in the courtyard to take advantage of a few faint aromatic breezes, and afterwards they would gather on one of the terraces overlooking the garden as the sky

darkened and the pauses between their remarks grew longer and more drowsy.

She cracked ten more eggs into the bowl and began to beat them.

That evening Giuditta waited in the shadowed arcade of the courtyard while the family dined, a long white towel glowing faintly on her shoulder. By the time they finished the last course, sweet crimson strawberries, her heels were aching in their flat sandals; she lifted one foot under her skirt, stroking it against her calf as her glance traveled across the courtyard to a white marble head on its plinth near the passageway to the garden. Squared at forehead and jaw, with a short, high-bridged nose, it looked like a Roman antiquity, but its model was the matriarch of the family, Caterina Novella, and its expression was significantly more alive and mobile than Caterina herself.

Caterina sat in her usual place at the head of the table, and her husband, Enrico, faced her from the opposite end. He was a tall, balding, olive-skinned man with thick lips and a nose curved like a zucchini. His glance darted and swooped around the courtyard but seldom rested on anyone's face.

At Caterina's right sat their eldest son, Carlo, a stocky, round-shouldered man whose twin passions were gluttony and the sound of his own droning voice. His wife and daughter were beside him.

The second son was in Rome on business, and his wife, Bella, was speaking about his most recent letter. She was a plump woman of forty, whose blonde hair was swept off her high pale forehead, looped and coiled with silk ribbons.

"His negotiations are taking longer than expected, so he must delay his return by a few days. I wish he could be here sooner."

"But not too soon," muttered Carlo's wife, Emilia. She was a thin woman, yet not angular; curves defined her shoulders and back, her prominent nose.

"Were you talking to me?" Bella asked. "What did she say?"

"I said you would rather have him come later because if he came sooner it would be inconvenient for you."

Bella thrust her jaw sharply upward, her double chin trembling like almond-milk jelly.

"What calumny are you hatching now?"

Once again the perpetual quarrel between the two sisters-in-law was ignited—when Bella spoke, Emilia disagreed, Bella answered back, and the disputes went on, day after day, as they had for years, even before Giuditta's time.

"I have heard that when Domenico is gone, you receive visits from the astrologer early in the morning or late at night."

"As usual, you twist my behavior into something else."

"One morning you were seen half-dressed as he was leaving—"

"Who told you this lie?" Bella leaned forward, glowering at Emilia.

"Someone who saw you."

A fortissimo cry erupted from Bella's mouth.

"That is a lie, a slander! It is a sin to spread such lies, you who pretend to be so pious, you twisted, serpent-tongued demon!"

She lurched out of her chair, knocking over a glass of red wine, which shattered against the courtyard stones.

"You have been vile and insulting to me ever since I married Domenico. Your vindictive tongue should be cut off and stuffed down your throat!"

No one spoke. Caterina stared ahead, her face as impassive as its marble copy. At the other end of the table, her husband gazed into the middle distance toward the loggia.

Bella pushed her chair back and stepped away from the table.

"Careful, careful," Giuditta said behind her. "Broken glass." She stooped down and began gathering the glinting slivers into her apron.

Bella stamped across the courtyard and up the stone stairway to the loggia. Carlo glanced at Caterina, then lifted his wine glass to his lips and emptied it.

Emilia remained with her hands flat on the table, her mouth stamped into a hard line. Then she glanced at Carlo, who raised his caterpillar eyebrows at her but did not speak.

Giuditta stood up and emptied the broken glass onto an empty plate.

"Thank you, Giuditta," Caterina said.

Bella was breathing hard by the time she reached the top of the stairway, and as she moved through the loggia toward her apartment, her breath seemed to gather in her chest and linger for a moment before it flowed out again, and even then she felt some of it held back. Trapped. As she had been for so many years with a stony, unfeeling mother-in-law, an aloof, ineffective father-in-law, and the hateful Emilia. The mendacious slut. How many times had she imagined the pleasure of wrapping her hands around Emilia's stringy neck and squeezing the last breath out of her?

She pushed open the door to the *anticamera* and slammed it shut. A circle of white linen glowed softly near the opposite wall; she went closer and saw that a small majolica plate remained on the table, a remnant of the afternoon's refreshment. She pressed the tip of her finger against the cookie crumbs on the plate—Giuditta's almond cookies—lifted it to her mouth and licked it.

Her footsteps were swallowed by the kilim carpet as she passed through the portiere to Domenico's empty bedchamber, redolent of books and leather and the strange dusty curiosities he loved to collect. Even if he had been there this evening, he would not have defended her, he had never taken her part over the years, and by now she knew he never would.

She was without allies in the palazzo save for the children, Pietro and Laura, and her friend Giuditta. Over the years, in the firelit vault of the kitchen, sitting at one of the long pine work tables with a flask of wine between them, they had gossiped and laughed, confided and lamented, and come to know each other as well anyone could.

Now she came into her own bedchamber and stood listening

through the open window to the clatter of dishes being carried out of the courtyard, the loud scraping of trestles against stone; soon the pigeons would venture into the courtyard on violet feet, looking for crumbs.

And the family, now beyond hearing, would have moved onto one of the terraces facing the garden as one or another of them began some interminable recitation while the others yawned and stared at their feet or up at the sky—Domenico and Enrico always stared skyward—until the droning voice stopped and a silence, heavy and torpid, closed over them like an enormous dome.

It was nearly dusk by the time the household staff finished its own dinner in the small staff dining room next to the kitchen. Giuditta left the two kitchen maids to clean up and went out the back door of the kitchen to the garden, where a tall hedge enclosed this part of the grounds containing the well and old Filomena's herb garden. Years ago, when she had just arrived from the country, her duties were to draw water from that well, weed and water the garden, pick fresh rosemary for roast chicken or basil for a sauce. More than eight years had passed since the old cook left to live on her nephew's farm, yet she still thought of the little garden as Filomena's.

She passed through an opening in the hedge, crossed the southern terrace with its row of potted lemon trees, and stepped onto the gravel pathway, which traveled straight ahead toward a great stone fountain.

Turning past the balustrade, with its statue of Neptune poised on the corner, she noticed a dark line meandering across Neptune's foot. She stopped and ran her finger across the line; the stone wobbled, and she saw it had already broken off from the rest of the foot. Not surprising. It was one of Domenico's Roman antiquities she used to stare at with awe, when she was young and knew so little of the world. That younger self who was amazed by such a garden, by the embroidered linen tablecloths and the silver and by Caterina's regal manner.

But as the years passed, she lost her enthusiasm for all of them except Caterina's granddaughters, Laura and Antonia, and Bella. Bella was the only one who ever praised her cooking, although it was remarkable that she even noticed what she was eating with Emilia at the table, hunched raven-like in one of her black silk dresses.

And it was Bella's shrewdness which had allowed the twelve-year-old Giuditta to become part of the Novella household. She had been born in a tenant farmer's cottage only a few miles away, cold every winter of her life and often hungry until she ran away to the city and met Filomena, who brought her to the palazzo.

There she worked hard and was grateful for the meals eaten with the other servants and for a place to sleep on the top floor of the palazzo.

One morning Giuditta was in the kitchen mixing dough, and Bella was there too, with the infant Pietro, when Caterina came in from the *saletta*.

"Who is this girl?" Caterina asked.

"I found her at the market, Signora, only a few weeks ago," Filomena answered. "She was hungry and dirty, and I brought her back thinking we could use more help in the kitchen. She works hard and is satisfied with little."

"Now I will have to begin paying her."

"She has come from the country, she would have ended up sleeping in a doorway...."

As Giuditta came to understand later, it was futile to appeal to the Signora's sympathy.

"She may stay this night, but tomorrow she must leave."

Then Bella made a suggestion.

"Let Filomena take the girl to her friend who is the cook at Palazzo Castellani. It is Filomena's opinion that Giuditta shows promise as a cook."

Caterina remained silent as if she had not heard. But the following morning, she relented. Giuditta stayed, and Filomena, smiling broadly, praised Bella's cleverness.

"The young Signora knows that Signora Caterina and Signora

Castellani have been rivals for many years. The Signora could not risk your becoming a renowned cook in the household of her rival."

Giuditta remained for a while longer in the garden, looking at the lawn with its sprinkling of daisies and buttercups, the row of cypresses against the back wall, and the undulating line of the *colli* beyond.

Back in the cool, deserted kitchen, she lit a candle from the oil lamp suspended over the hearth and followed its little yellow peak to the back staircase. She climbed one flight to the *piano nobile* and continued along a narrow corridor which traversed almost the entire length of the palazzo before angling left toward the loggia. And here it joined a second passageway leading past two rooms—the first belonged to Ottavio, the *maestro di casa,* and was considered by him the better one because of its distance from the street.

Her own room at the end of the passageway had two windows overlooking the street, and all of its noise and dirt were her companions. Closing the door behind her, she heard something stir, then her black tom, Lorenzo, lifted his head from the far end of the bed and chirped a greeting.

"Soon, Lorenzo."

She put the candle down on a small table near the window, pulled the shutters open, and leaned out to behold Il Duomo, darkly solemn against the indigo sky.

two

TADDEO HAD BEEN WALKING SINCE DAWN, his eyes fixed on the red dome of the cathedral. At first it was only a small bubble in the distant valley, then as the sun rose higher, lifting the shadows with it, the dome ripened into a rosy melon high above the city walls.

By the time he reached Porta alla Croce, his face and hair were damp under the broad-brimmed black hat; once inside the gate, he leaned against the brick and stone wall and watched people coming and going across the piazza, more people than he saw in a year in the country. A brown-robed friar with a gaunt, pale face. A farmer carrying a lamb, his own white hair as curly as sheepskin. A donkey laden with firewood, hooves clacking on the stones. A man in a fur-trimmed surcoat, leading a white horse.

And the stench, he had forgotten that since last time, the filth and offal streaming through the gutters.

He was still sweating, and his throat was dry, but he could not stay hunched against the wall all day.

He followed a miller's donkey past some shops on the piazza—the scent of fresh-baked bread floated above other odors

like the highest voice in a choir—and down a narrow street. This narrowness, and the darkness of the street, with steep black shadows falling halfway across like raven's wings, made his skin prickle apprehensively.

He passed a church, then came into another piazza and saw the cathedral ahead to his right. There were two streets going west on the other side of the piazza, but he couldn't remember which one would take him to via del Proconsolo.

A donkey cart filled with laundry clattered by; two gentle-women with their maids strolled in front of him.

He called to one of the maids. She glanced at him, and he took off his hat and hurried after her, loping alongside to ask the way to the palazzo. The street to the right, she said, without looking at him.

The street he turned down was lighter than the others because many of the old wooden cottages were being torn down to make way for new palazzi. It was dusty and filled with rubble from construction, so it was some time before he reached the end of it and recognized the Palazzo Novella.

He crossed the street and stood opposite the palazzo, a three-story stone building rising above the cluster of small houses and shops. He tilted his head back to study it: the deep cornice, like the brim of his own worn black hat, cast a band of shadow across the upper floor and the row of small round windows extending across the facade.

Below this, the windows were arched and parted in the middle, their shutters closed against the heat. On the ground floor, four large rectangular windows covered with iron grilles were set into the rusticated stone.

The great wooden door in the center of the building stood open, and he could see through the cool vault of the entryway to the courtyard. Last year, the last time he came, he had seen their cook, a woman whose image had stamped itself so strongly in his memory that he was able to carry her back to the country with him.

His heart fluttered—he saw someone, a woman, coming

through the entryway into the street, moving with long swift strides. He stared speechlessly: she was just as he remembered, tall and ample, with broad cheekbones, a wide mouth, and thick braids of coppery hair wound around her head.

Taddeo bounded across the brick-paved street and through the entryway to Palazzo Novella.

three

BECAUSE THE YOUNG FRESCO PAINTER Alessandro always ate standing up, Giuditta brought him food that he could pluck off the plate with his fingers.

On the day he began, she had noticed, while crossing the courtyard, the supple angle of his back as he leaned toward a section of fresh plaster. His clothing was simple—a grey doublet and hose one shade lighter than the wet plaster—and his honey-hued curls reminded her of the angel Gabriel.

At midday she sent one of the kitchen maids out to him with salami, bread and cheese, and would have continued to do so had she not stopped to speak to him later as he was cleaning his brushes.

"What is the subject?"

"Everyone wants an Annunciation."

"So this is…?"

"Adam and Eve and the serpent." She saw that his face was lightly tanned, with rose on the cheeks, his eyes like medallions of bright aquamarine, his lips full and gently curved.

Thereafter it was she who carried salami and bread to him.

Today she had arranged dewy green crescents of melon,

rosemary bread, goat cheese and olives on an earthenware plate. She covered the plate with a napkin, picked up a small netted wine bottle, and passed through the kitchen and the servants' dining room into the courtyard. Her glance tracked across the courtyard to the northern wall of the arcade, where Alessandro stood with his back to her, stroking green onto a leaf.

The sound of flapping wings caught her attention as two pigeons took flight from the balustrade of the loggia and soared over the red roof tiles. Glancing up, she saw Emilia talking to someone whose back was turned to the courtyard. He was unusually tall and thin, and his dark hair sprouted in jagged locks beneath his broad-brimmed black hat.

She stopped to watch, balancing the plate on one hand. Emilia said something, then the tall man turned, and she saw a beak of a nose and a high ridge of bone above sunken cheeks. Ugly as a crow.

Now she continued toward Alessandro and stopped just outside the arcade to watch him paint. A garden was emerging on the upper wall, its trees laden with blossoms and golden apples, brown trunks sprouting beneath like long beards. In the center of the painting, the leaves were swept back like a curtain, showing the hills beyond. To create such images took concentration and a refusal to be distracted; in the two weeks she had been bringing food to him, he barely looked at her or spoke, aside from a mumbled thanks when she handed him the plate.

He turned away from the wall and laid down the brush. She handed him the plate, and he whisked the napkin off and picked up an olive between two slender fingers and eased it into his mouth. Then he turned back to the painting and stared at it, as always, while he ate. Maybe he was afraid of her. Maybe she had been looking at him with too much appetite.

She heard voices above in the loggia, growing louder. One was Emilia's—deep as a young man's—then she heard her daughter Antonia as well.

"You must stop asking me about it," Emilia said, "because I will not consider a marriage with Simone Alberti."

Simone was the young man Antonia had cast coy glances at one morning in church; he appeared thereafter in the evenings outside the grill-covered windows on the ground floor, with Antonia whispering and giggling inside like a caged canary. Giuditta knew who he was because the Alberti family's cook was her best friend.

"I can speak to Grandmother...."

"She would be even less likely to do what you want. They are not the kind of people—"

"Who do what?"

"They are not like us."

"Who do you think we are? They are merchants like us, and they live in a palazzo that is bigger than ours."

"They made their money too recently."

"Why does that matter? Does money have to be aged like wine?"

"At your age you cannot understand."

"Who do you have in mind, Mother, that fat son of Signora Salviati? The one with the squint?"

"Leave me alone now, I was on my way out."

"Wait! Have you and Father already talked to the marriage broker?"

"We do not need your permission to talk to a marriage broker."

"No!" Antonia shrieked, "you will not! You will not force me."

Alessandro twisted around and looked at Giuditta. She shrugged and started toward the young painter, but before she could say anything, Emilia marched down the staircase, followed by her maid. The muscles of her face were taut, her mouth grimly clamped, with one eyetooth pressing into her lower lip. As she advanced toward them, Alessandro handed the empty plate to Giuditta and turned back to his painting.

Emilia stopped and glared at the wall.

"That is a useless waste of money."

"Foolish windbag!" Alessandro snarled.

"Insolence!"

"Peace, peace!" Giuditta stepped in front of him, cupping her hand over his raised forearm. She felt the tension in his muscle, the warmth of his skin, then the slow release as he lowered his arm. She let her hand linger there until Emilia turned away and clattered across the courtyard toward the entryway.

"A little arsenic in her spinach," he said.

Giuditta laughed.

"Who is she married to, and how has he refrained from murdering her?"

"She is married to Carlo, the oldest son. He loves her and thinks she is without blemish."

Listening, with his eyes lowered, looking sideways at her through his lashes, he looked like Donatello's *David* in the Piazza della Signoria.

"Who can tell what makes two people love each other?" she said.

For a moment, his eyes were beautifully moist and shining, then he shrugged and turned back to his painting.

She picked up the empty plate and carried it back to the kitchen.

The next day, Wednesday, he turned away from the wall and smiled at her when she came, and she felt a tingly flutter in the pit of her stomach. He ate quickly, as always, but this time he spoke to her about his apprenticeship with Maestro Botticelli.

On the way back to the kitchen, she noticed a familiar burly figure coming through the entryway—the music teacher Angelo Villani, who came every Wednesday to instruct Laura and Antonia. He was shorter than Giuditta, with a low forehead and slanting, almost lidless eyes. His hands, however, were graceful and well manicured: she had discovered this the time he used them to grab her and a moment later found himself sprawled on the courtyard stones, while two housemaids giggled overhead from the loggia.

Coming into the kitchen, she found Bella sitting on a rush-

bottomed chair at the far end of one of the long oak tables. She often came into the kitchen to watch Giuditta work, to taste and comment and tell stories which made Giuditta laugh.

The kitchen was a large room with a vaulted plaster ceiling, an oak plank floor, and four doors—one leading to the family dining room, the second to the servants' dining room, another to Ottavio's office, and the fourth outside to the garden. On the left side of this door was the old lavatory, a marble basin with an old brass pail suspended above it on an iron chain. On the right side gleamed a new marble sink, swelling upward like a beautiful shell, with two pewter taps. Above the sink, the shutters of a narrow window opened into the room.

The hearth dominated the middle of the north wall, and a new brick stove stood beside it. Plates, saucepans and casseroles were displayed on long open shelves on the opposite wall.

At a small table between the shelves and the lavatory, the young kitchen maid Clarice slouched over the wash basin. She was a thin, pale girl with large green eyes in a narrow face. Giuditta handed the empty plate to her and turned to Bella.

"What are you planning to do with that?" Bella asked, pointing to a large cut of beef in a tray on the table.

Lorenzo was stretched under the table, waiting.

"Garlic," Giuditta said. "Almonds, pine nuts, rosemary, mint, cinnamon and wine."

Bella licked her lips and touched her fingertips to her necklace, a circle of golden and garnet beads, a gift from Caterina.

"Did you hear Emilia and Antonia yesterday?" Giuditta asked.

"I was just outside our apartment. It was unavoidable. Have you ever seen this Simone?"

"Once, when I was coming back from the market, I saw him outside one of the front windows talking to Antonia. I saw him well enough to recognize him the next time, near the cypresses, although they were too busy to notice me. The third time, a few nights ago, I saw him in the dark, coming down the back stairs."

Bella laughed, a soft delighted chuckle.

Giuditta walked a few steps over to the garden door and opened it. Bright yellow light flooded through the arched doorway, and the cat lifted his head and blinked.

"Come outside," Giuditta said, "and help me pick the mint and rosemary."

Bella had paid little attention to the young painter until one morning, as she was leaving the palazzo to look at fabrics for a cloak, she was attracted by the harmony of the colors on the emerging fresco, and she stopped to examine his work.

She saw that Adam's face had been finished, but Eve's remained in outline, with a high round forehead and long blonde locks spiraling down to her bare shoulders. Among the lower leaves of the apple tree, just touching Eve's hair, a bright triangular shape caught her eye—a serpent with a woman's face. Emilia's face.

She moved closer; the painter turned, wiping his brush, and looked at her.

"That face," she said. "The serpent."

He laid his brush down beside his palette without answering.

"Is it intentional?" she asked.

He shrugged, averting his gaze.

She moved closer, and he looked at her. His eyes were a brilliant blue, guileless.

"It is her," she said quietly. "Signora Emilia."

"Yes," he said in a low voice. "My small revenge."

four

BEYOND THE WHITE NET CURTAINS OF the canopy, sunlight molded a gilded frame around the oak shutters facing Antonia's bed. She stretched, yawning, under the quilted coverlet, and the balled fists of her extended arms banged against the paneled headboard.

She banged them again against the wood. How many hours to wait before she saw Simone again? It was nearly eight now; Mother, up and gone before anyone else, would still be at mass. Four hours to wait before she met him in the garden.

Thinking about Mother made the inside of her throat swell angrily. The way she wanted to control everything, the way she always questioned her and poked into her thoughts, even the most private. Then she had to fight back, clamping her mouth tight and refusing to answer while the anger glowed like little brazier fires in her throat and chest.

A church bell sounded, confirming the hour. The door opened, and Giovanna, the maid, came in, lifted the curtains away and hitched them back on either side of the bed like the wings of a gigantic bird.

Antonia swung her legs over the side of the bed and rested

her bare feet on one of the bed chests, while Giovanna unlatched and opened the shutters. Sunlight plunged into the shadowy room, and a breeze swayed the looped curtains. It would be sunny and warm when she went to meet him in the garden, and the grass would be bright with poppies and daisies.

Now Giovanna stood before her with a towel draped over one shoulder, holding a bronze ewer and basin. Antonia held out her hands, and the girl poured a stream of rosewater over them. She washed her face and neck, then she held her dripping hands out and studied her fingers: they were short and thick, like candle stubs, with bitten-down nails. After she and Simone were married, she would stop being anxious, and she would stop biting them.

As for this morning—she would dress and go down to the dining room for the morning meal as usual, but instead of joining the others in the loggia afterwards, she would return to her room, and at noon, she would slip down the back staircase to the garden.

She stepped onto the cool tile floor and lifted her arms into her chemise and let Giovanna tug it down over her head. Stockings and shoes went on, then the dress. She picked up the little Murano hand mirror and stared at herself as Giovanna began combing her hair. Eyebrows as straight and dense as Father's, like an angry dart in the middle of her face. Her heavy jaw clenched, her mouth tightened like a drawstring purse. An ugly face at the moment, but in a few hours, Simone would be waiting for her in the garden, and he would kiss her, her face would soften, and she would be beautiful.

Giuditta was never in so great a hurry, moving through the city's meandering streets, that she failed to appreciate the sky's gleaming color, like lapis lazuli, and the keen transparent light that sharpened the edges of buildings, or the way shadows fell steeply into the narrow streets and cloaked the paving stones with black.

This morning was no different as she returned to Palazzo Novella carrying a basket of eels; the kitchen maids ambled behind her carrying the vegetables and chattering.

They had reached via del Proconsolo; she waited until an old hay cart rattled by, then she crossed the street. The footpath was almost empty ahead of her except for one man, moving with his shoulders hunched and his head thrust forward like an old man. Watching Angelo Villani turn into the palazzo's entryway just ahead of her, she wondered why he had come on a Friday.

She turned the corner onto Borgo degli Albizzi and continued until she came to a side door, where she let herself and the two maids in. They followed her through a dark storeroom into Ottavio's office, a small chamber next to the kitchen.

Ottavio's desk stood on a low platform, with a black ladderback chair behind it and a tall iron candlestick beside it. He was seated at the desk when they came in. He looked up and gestured toward Giuditta with the point of his pen.

"The Signora wishes you to confer with her in her apartment."

She went into the kitchen to wash her hands, leaving the fish for the maids to clean, then through the staff dining room to the courtyard. She had observed earlier that Alessandro was absent, and aside from a few pigeons pecking at the stones, the courtyard was empty.

As she started up the front stairway, she met Domenico, the Novellas' younger son, coming down. He was a portly man with fine black hair and skin that looked like raw pastry dough.

"Good morning, Signor. How was your journey from Rome?"

"Tiring, very tiring," he said brusquely, without looking at her.

At the top of the stairs, she strolled through the loggia and entered the door leading to Caterina's *anticamera*. For a moment, the pale fan of light from the open door brushed the glazed terracotta floor tiles; then she closed it and the light withdrew, darkening the walls with their paneled woodwork and silken wall hangings. Silk covered the chair cushions in the palazzo and was suspended on rods around the great beds; silk damask

crowned the bedclothes with its richness, and the whisper of it followed the women of the family across a room.

The family fortune had grown from the silk business Caterina's father began; when he died, Caterina, his only heir, took his place, and she still ran the business with her two sons subordinate to her, and their sons running branch offices in London and Paris.

"Oh, Giuditta." Caterina came in from the bedchamber with her slow, limping walk—as an infant she had fallen from a bed and broken her right leg—stopping a few feet away, where light from an open window haloed her silver hair with soft highlights; the blue of her eyes was nearly transparent.

"We are giving a banquet next week for some visitors from France, five or six." Her voice moved in a slow, dull cadence.

"We should begin with melon as usual...."

"Then prosciutto with capers."

"Yes."

"Rabbit stuffed with carrots. Roasted chicken."

"And asparagus if they bring some from the estate."

"Trout after that, Signora. Spinach ravioli, fried veal, sweetbreads, and liver with eggplant sauce."

Caterina hobbled toward a portrait of the Madonna in a gilded tabernacle, as if she needed to consult her. Giuditta was about to suggest strawberries, still at the peak of sweetness in June, when a terrifying scream ripped the air. The words froze in her mouth as Caterina turned slowly toward her.

"What else?"

"Strawberries—" More cries, and high-pitched shrieks reached them, and she stared at Caterina for an indication of what they should do. The Signora looked at her blankly, and now they heard wailing and shouting, and the sound of people running.

Giuditta turned and ran through the *anticamera* into the loggia; leaning over the railing, she saw people converging in the courtyard near the passageway to the garden. She hurried down the staircase and caught up with the grunting, pushing horde

trying to jam through the passageway. She moved with them into the corridor and was pushed against its rough stone wall, stumbling as she came out onto the gravel pathway. Here tall hedges shaded the path on either side, and just beyond lay the terraces, each with its statue-crowned balustrade, stone benches and potted lemon trees. Beyond them, the path traveled straight through the daisy-starred lawn, then branched into two wider paths around the stone fountain.

Some of the servants were huddled near the fountain; Giuditta pushed her way along the gravel path until she reached the fountain and saw Antonia on her knees, her mouth rounded into a cavern of horror. Simone was beside her.

Emilia was lying on the ground, one cheek pressed to the gravel, her right arm arcing around her head, her feet in their high-heeled shoes angled inward. Her left hand clawed the small stones, and a chunk of broken statuary lay an arm's length away, as if she had either thrown it or were trying to reach it.

Growing pale, unadorned by cosmetics or jewelry, Emilia lay devoid of vanities in her final hour.

five

THE ONLOOKERS MOVED BACK, MAKING
way for Carlo and Caterina. Silence surrounded them
like a black veil.

"Emilia?" Carlo knelt awkwardly beside her and swept a few
strands of blood-matted hair away from her face. He turned her
gently onto her back, and she stared upward with clouded eyes.
On the ground behind her head, blood from her wound was
darkening into a deformed halo.

"Mother?" he said in a choked voice.

Caterina stepped closer, and Antonia stood up, whimpering,
and flung her arms around her. Caterina winced; Carlo began
sobbing.

Ottavio moved next to Caterina and spoke to her in a quiet
voice. One of the younger men servants lifted Emilia off the
ground, but her black veil, the drying blood stain, the broken
statuary—part of Neptune's cracked foot—remained as a grisly
still life. Had she tried to use the stone to defend herself, drop-
ping it when she fell, or was Neptune's foot the murder weapon?

Suddenly Ottavio bent down and scooped something up,
closing his hand around it. Then he rose, and with a slow,

ostentatious gesture held it dangling from his fingers—Bella's
gold and garnet necklace.

Giuditta came into the *sala* so rarely that each time she felt over-
whelmed by the polished terrazzo floor, the tall windows of
crystalline glass, the splendid blue paneled ceiling with a gilded
rosette at the center of each panel and smaller rosettes fastened
where the framing ribs crossed.

The walls were a lighter shade of blue, frescoed with a pat-
tern of white irises.

All the servants were assembled there on the morning after
Emilia's death, seated on high-backed wooden benches on either
side of the great fireplace. All except Ottavio: he and the mem-
bers of the Novella family were seated in an uneven circle of
chairs near the doorway to the *anticamera*.

Caterina nested, with her back to the doorway, in an arm-
chair upholstered in burgundy velvet. Her small, wrinkled hands
gripped the arms of her chair, and she stared broodingly at the
north-facing windows. She seemed smaller this morning, as if
she had dwindled during the night.

An identical armchair stood empty beside her as Enrico
paced back and forth along the width of the room, prating about
Emilia's family, who were silk merchants in Lucca. On one of his
rounds, he bumped against a small walnut table beside Caterina's
chair, jostling Neptune's broken-off foot on which blood and
some hair had been found yesterday afternoon.

Carlo and Antonia were sitting beside each other; Carlo's
face was blanched, his eyes puffy and red rimmed. He leaned
back in his armchair, with Antonia resting her head against his
chest, and their joined hands resting on his thigh.

On the other side of the circle, Bella and her daughter Laura,
a petite girl of fifteen, meticulously attired, held hands, but
Domenico had placed himself somewhat apart from them, sit-
ting in his usual way—legs apart, hands on his knees, his head
tilted sideways and upward.

Ottavio sat stiffly in a narrow black chair, his dark-eyed

glance moving from face to face. Suddenly he looked toward the doorway and leaned forward slightly as the white-haired porter shambled into the room, followed by three policemen in green livery. Two were young, the sturdy muscles of their calves nicely outlined in their green hose.

The third man, older and half as tall, strutted into the *sala* with his chin held high, acknowledging no one until he reached the middle of the room. Then he lowered his chin abruptly, and his glance arced through the room like a sabre. His green eyes were set in deep hollows like prisoners in a dark stone tower. Shadows hollowed his thin cheeks, his mouth was clamped so tight it seemed lipless, and his voice, issuing from a thin parting of the clamped lips, was shrill. His name was Soderini.

"Who found Signora Emilia Novella?"

No one answered. Antonia huddled closer to her father.

"Antonia.... Her daughter," Caterina said, gesturing toward the girl.

With short jerky steps, he moved into the circle and stopped in front of Antonia. He glanced at Carlo.

"You are the husband, Signor? Yes? You miss your dear wife?"

"She was my wife," he said flatly.

"Signorina Antonia, where were you when you found your mother?"

"By the fountain." Her voice trembled. "In the garden. I found her on the path leading to the fountain."

"What were you doing in the garden, Signorina?" He bowed close to her, hands clasped behind his back.

She looked down, clenching her right hand into a fist, and a lace handkerchief foamed white between her thumb and forefinger.

"I was talking to someone."

"Talking to someone. Where?"

"Near the back wall, by the cypress trees."

"Did you hear any cries or shouts?"

"No," she whispered into her lap.

"Did anyone hear or see anything?" He spun around on the heel of his boot, his glance swept the room, touching each face like an accusing flame.

"No? No one?"

No one answered; the room swelled with tense silence. Outside a cart rattled by, and a woman shouted at someone. Bella shifted position in her chair.

"How many entrances are there?" He was looking at Domenico, but Caterina answered.

"Besides the front entrance, there are two side doors for the servants. Each servant has a key to both doors. The other entrance is through a gate in the garden wall, which leads to the stable. The fence around the stable has a gate leading to the street."

"In the front.... Where is the porter?"

Head thrust forward, fingers clutching his little woollen cap, the old porter came forward.

"Who came here yesterday?"

The old man stared at the floor and moved his lips as if he would answer but for a long time made no response.

"I cannot remember everyone who came, but no one entered the front door who was unknown to me."

"The murderer was already in the palazzo or known to you."

The porter shrugged and looked toward Enrico, standing by the fireplace.

His mouth pressed into an unforgiving line, Soderini began moving slowly past the benches where the servants sat, his glance lingering on each face. The only sound was the rap of his boot heels on the marble floor.

Then, as he turned and retraced his steps, Giuditta glanced boldly into his eyes—they were like the Friar Savanarola's, the one time she heard him preach, green and flashing with menace.

He stopped and rested one hand on the back of Ottavio's chair.

"Why was no cry heard, Signorina Antonia?"

The girl bowed her head and pressed the handkerchief to her eyes without answering.

"Because there was no struggle," Carlo said. "My wife was attacked from behind, and before she could cry out she was struck on the back of the head with...." His plump, trembling hand held the chunk of marble out to Soderini.

Soderini's bony hand darted toward the fragment, and he cupped it in his palm, turning and stroking it.

"Who would have done this? Who was her enemy?"

"She was!" Antonia cried, pointing at Bella.

"She hated my mother. She fought with her constantly. Last week she said someone should cut her tongue out and stuff it down her throat."

"This," Carlo said, drawing Bella's necklace out of a pocket in his surcoat, "was found beside Emilia's body."

Bella gasped, her white, dimpled hands fluttered to her mouth; Domenico's moist skin turned ashen. Soderini snatched the necklace and flourished it before Bella.

"Is it yours, Signora?"

"It is hers," Caterina answered. "It was a gift from me."

Bella's face reddened. She cast an angry glance at Caterina.

"It is mine, but I am not the murderer. I was in my bedchamber, I knew nothing about it until they found her."

"I will keep this." Soderini knotted his hand around the necklace and nodded crisply to the other policemen.

"Arrest her."

Afterward Giuditta would not be able to forget Bella's look of bewilderment when she heard Soderini's order, and the way her mouth curved into a circle of astonishment as the two men came toward her with their heavy tread. Now all of the servants had risen, murmuring to each other as the policemen grabbed Bella's arms.

"Domenico, for the love of God, help me!" She twisted her head around, trying to look at him. Laura was crying loudly as they led her mother forward. Again Bella struggled and tried to twist out of their grasp, and as they turned her toward the door,

she could see her husband cringing on the edge of his chair, his hands squeezing its velvet arms.

"Domenico, why don't you help me, you spineless fool? May the Devil throttle you!"

Caterina laid a restraining hand on Domenico's arm, and he remained seated as they led Bella toward the doorway. Soderini followed, then Laura, and the servants rushing after, through the *anticamera* into the courtyard.

Giuditta shoved her way through the mass of bodies and ran ahead up the stairway as the police came forward with Soderini in front, then Bella—loops of her blonde hair were coming undone, straddling her shoulders, and her face was damp with sweat and tears.

"Signora Bella!"

Bella's eyes rolled, flashing white, and she saw Giuditta leaning toward her from the stairs.

"Giuditta, help me! You must help me! You are my only friend here."

"God save you, Signora!" Giuditta shouted as Bella disappeared through the entryway, with the servants following like a noisy wake.

But Giuditta remained on the stairs, listening to a small voice inside her—a wordless knowing, an intuition—which urged her upstairs to the *piano nobile*. Just past the head of the stairway was the door to Domenico's *anticamera*; she slipped in quickly and hastened through the room to the second doorway, into Domenico's bedchamber.

Here she stopped and listened. Voices swarmed in the courtyard, loud and agitated, but she heard no one in the loggia or in the *anticamera*.

Her tread softened as she crossed the kilim carpet and passed through the embroidered portiere to Bella's bedchamber. The walls of Bella's room were paneled with dark wood, which included the tall headboard—the great bed itself extended halfway across the room, surrounded on three sides by flat-lidded bedchests. A hooded fireplace occupied the remaining space on

the right side of the bed; on the left stood a small inlaid table with a bronze basin and ewer.

Light flowed from a single window opposite the bed and was reflected in several glass mirrors; Bella's dressing table stood beneath one of the mirrors, and near it was a small wall niche with a door. She stopped in front of the little door and closed her eyes for a moment to listen, but beyond the sound of her own urgent pulse, she heard nothing.

She opened her eyes and touched the gleaming bronze handle; the tiny hinges creaked as she opened the door. Three small shelves full of bottles and jars—tooth powder, lemon juice, lip color, almond oil skin cream. Bella's familiar scent was composed of this, a fragrant, beseeching remembrance.

She closed the door and sat down on the small chair in front of the dressing table; Bella's ivory-handled comb lay there, her brush and nail scissors, and a small blue flask of perfume.

Footsteps sounded outside in the loggia, and she held her breath until they passed the doorway. The only way out was the way she had come in. What if Domenico came back and found her there? What explanation could she give?

In the corner opposite the portiere stood Bella's massive oaken *cassone*, painted with birds and flowers. Giuditta knelt before it and lifted the heavy vaulted lid; the scent of lavender floated up from the crimson velvet lining and the layers of silk and satin dresses. Her fingertips glided over a yellow satin dress, then gently delved beneath and touched something with a hard straight edge.

Folding back the rustling satin, she lifted up a *cassette* covered in crimson silk. She stood up and carried it over toward the window's soft, luminous light to open the lid.

The box was lined with matching velvet, and nesting alone on the soft crimson pile lay Bella's gold and garnet necklace.

six

HUMMING A MELODY OF HIS OWN COMPO-
sition, Angelo Villani was on his way home from a visit
to the hosier, where he had placed an order for two
pairs of rust-colored hose. The day was growing warmer, and he
anticipated stopping in The Little Snail for a few hours before
returning to his room in Borgo Santa Croce. He was about to
cross via del Proconsolo when the sound of chanting voices
caught his attention, and he glanced up the street toward Palazzo
Novella. Torchbearers in black and white livery were advancing
toward him, and behind them came the pallbearers and the
priests.

He remained on the footpath with his worn felt cap pressed
against his heart as the procession turned into via dei Pandolfini.
What did Signora Emilia look like now, wrapped in white mus-
lin, her piercing eyes shuttered above her beaky nose, her bitter
mouth silent? Now there would be no more comments to his
face about the uselessness and frivolity of music lessons; he had
always controlled himself when she demeaned him, but in his
mind he saw himself wrapping a lute string around her neck and
jerking it tight.

His fingers twitched. He saw a heavily veiled Antonia pass-
ing him, with her father. Signora Caterina and Signor Enrico
followed, the old man's haughty chin thrust upward, the
Signora's hand resting on the old man's proferred forearm. The
gesture surprised him although it was a common gesture among
women. But the Signora was not like other old women, she was
more like a man; she never wasted his time with idle talk but
went immediately to business, and she always paid promptly for
music lessons or a performance at one of her banquets.

Signor Domenico came next, and Laura, staring at the
ground. Then many people he did not know, their heels clatter-
ing on the paving stones.

He nearly failed to recognize Giuditta when she went by,
walking with slow measured steps instead of her usual easy saun-
ter; when he understood it was she, yearning coursed through
him like the Arno in flood, and he ground his front teeth to-
gether.

As she turned down via dei Pandolfini, he remembered he
had been on his way toward Santa Croce, and he crossed the
street and joined the last of the mourners.

A few days later he waited for an hour outside Palazzo Novella
before she emerged from the side door on Borgo San Piero, then
he started after her. His glance oscillated between the brilliant
rust of her hair and the grey paving stones as he walked, pro-
ceeding with great caution because of his new knee-high boots.
He walked around puddles, stepped over excrement and slippery
garbage piles, his head in its new velvet cap bobbing up and
down as he trailed her.

She stopped in front of the Badia, but a moment later she
moved on, walking more slowly, toward Piazza di San Firenze.
The piazza was crowded, and he thought he had lost her until he
saw her again in front of Palazzo Gondi talking to another
woman. Her smile gleamed, and she touched the woman's arm
before turning into the street leading to Piazza della Signoria.

He moved faster, no longer looking down, afraid of losing

her once she reached the piazza. The shaded street rose gradually until, at its crest, one of his favorite vistas appeared, the ochre and buff stones of the palazzi across the way and the radiant blue sky rising above them.

Nearing the piazza he heard the familiar music of its voices, a harmony so unique he could be taken there blindfolded, and he would still know exactly where he was.

Coming into the piazza, he hurried after her as she continued past a group of men in passionate discussion. Suddenly she slowed down as if something had caught her attention, walked back a few steps and stopped in front of one of the statues on the terrace of the Palazzo della Signoria.

He could not see what she had stopped for. He walked around until he was standing in back of her with a good view of the statue, a woman of gleaming bronze. The fingers of her left hand clutched a slain warrior's hair; a sword was raised in her right hand, and her sandaled foot bestrode his arm. It was Donatello's statue, taken from the Medici palace when the family was driven into exile two years ago.

Now she turned away, smiling to herself.

Several old men were resting under the arches of the Loggia dei Lanzi, watching their fellow citizens; he saw their heads swing like weather vanes in a sudden gust of wind as Giuditta strode past them. Just beyond the loggia, she slowed down and stopped at a glove seller's shop; her back was turned to him as she leaned toward the rows of gloves. He glanced down at his own new pair, scented with rose and lavender, and moved toward her as she picked one up and began to pull it on.

He waited.

She held out the gloved hand and stroked the leather, and she seemed to be asking the price; a moment later she laid the gloves back on the counter and moved away.

In a few swift steps he was beside the counter, opening his purse; he snapped a florin and five *lire* down, grabbed the pair of gloves and loped after her.

"Signorina Giuditta!"

She slowed and glanced over her shoulder. He saw a twinge of annoyance tug at her mouth as she watched him come toward her in his new boots and rust-colored hose, his new green satin doublet and blue velvet surcoat.

He waited for her to smile at him, for appreciation to animate her face.

"What do you want?" She was scowling.

"Only the pleasure of having you accept this gift." He bowed and held out the gloves.

"I cannot accept them," she said and started to walk away.

"One moment!" A crescent of bare shoulder was turned to him; he wanted to touch her lightly there, on the moist freckled skin, but he dared not.

She turned around, her arms crossed, one eyebrow arched.

"Am I to believe you are as selfless as an angel?"

"It is as simple as that. I want nothing more than the pleasure of giving. Do not look for five legs on a sheep."

Her glance flickered over him, head to toe, and she shook her head.

"I cannot accept your gift."

He trotted beside her as she started toward the river.

"If you would permit me to ask about the young lady, Antonia. I was told not to come for the lesson this week."

"Have you not heard of the murder of Signora Emilia? Antonia mourns, with her father."

"When? The poor woman! Who is suspected?"

"A week ago. Laura's mother was arrested for the murder and taken to the tower in Piazza Santa Elisabetta—"

"The Pagliazza?"

"To be imprisoned even though she is innocent."

She hesitated on the footpath as a mule laden with pottery went clanging past. When the noise had subsided, he said, "How can they arrest an innocent woman?"

"How can they? You know how things work." She sliced the air vigorously with one hand.

"They can be influenced by the powerful ones. It makes me

furious." She glared at him, and he moved back a step, tongue tied by her ferocity.

Then she moved away, and he watched her cross the river road toward Ponte Vecchio but did not follow her.

seven

I TRIED TO GET RID OF HIM, BUT HE FOLLOWED me all the way to the bridge. Strutting around in his new clothes. It is enough to make the chickens laugh."

Veronica rested her hands on one knee and glanced across the piazza at the silhouette of Santa Croce. She was a few years younger than Giuditta, and her face, with its fair skin, a high brow tapering to fine cheekbones, and a small, pointed chin, was remarkably beautiful.

"Do you fear him?"

Giuditta shrugged. "My sense of him is such that I would not trust him."

Veronica knew him better: he rented a room from the Alberti family in Borgo Santa Croce, where she was the cook.

"When he started wearing the new clothes, we wondered how he had paid for them, and some of the women joked with him about it, but no one could find out anything. Then this morning one of the grooms said he and Villani and the coachman were drinking at The Little Snail, and Villani boasted that he was paid to kill someone."

"Emilia!" Giuditta rocked backwards as if she had been struck.

"He usually came on Wednesday to give the girls their lesson, but I saw him that Friday when I was coming back from the market." She clutched Veronica's wrist.

"He asked me how they could arrest an innocent woman, Mother of God!"

Veronica hunched her shoulders.

"How do you know she is innocent?"

"The necklace, the necklace. They arrested Bella because a necklace of hers was found beside the body. Ottavio found it. After she was arrested, I immediately went to her room, although I did not know what I was looking for. But I kept looking, and I found the necklace in her jewelry box. Then I knew someone had copied it and given the copy to the murderer to leave there."

"Who would want to kill Signora Emilia?" She tucked a fallen wing of reddish-gold hair behind one ear.

"Ah!" Giuditta shouted, throwing up her hands "In my opinion, almost everyone who knew her."

During all the time Giuditta had worked for the Novella family, Carlo's appearance had scarcely changed—the dark, tightly curled hair greying a little, the rounded lines of his double chin growing fuller over the years. Two weeks after his wife's death, the chin had contracted to folds, a pair of cheekbones edged forward, and his eyes were red rimmed and circled with dark. He appeared at meals because Caterina insisted but left most of his food untouched.

Sometimes his doleful wailing could be heard through the tapestried walls of his apartment.

Giuditta and Veronica agreed that any man who cried and lost interest in food was not a murderer.

During the early days of her imprisonment, Bella had paced the length of her dark cell hour after hour, the fetid straw crackling under her velvet shoes as she relived Soderini's interrogation and the humiliation of her arrest. As she walked, fleas leapt out of the

straw onto the tender flesh of her ankles and feasted there until her ankles were ringed with bites; when she lay in fitful sleep on the thin straw pallet, they found her wrists and arms, the folds of her plump neck.

Finally, on the fifth day, the bolt was lifted outside the iron-studded door, the hinges groaned as the door swung inward, and Domenico came in. He wore a black pillbox hat, a tunic trimmed with marten fur, and black hose covering his heavy legs.

He looked at her as if waiting for her to speak.

"Are you mute?" she said.

He came a few steps closer, a cloudy shadow trailing behind him.

"Am I free to go?"

His wispy eyebrows drew together, and he rubbed his hand across his upper lip.

"Not until the trial is over, dear Bella."

"I am innocent. There cannot be a trial."

He shrugged, and she lunged at him, grabbing one wide silk sleeve.

"You let this happen! Why are you not working to free me?"

He tugged at his sleeve, and she grabbed more of it in a tight fist.

"I will have to consult with Caterina." That slow flat tone he used when he was provoked.

"No! Not Caterina, she thinks I am guilty. Go yourself to speak to the magistrate. Yourself!" In the dim light, she could just discern the narrowing of his pupils.

"I heard you," he said, hunching one shoulder.

He turned away and walked through the open door without looking back.

The graceful strokes of Alessandro's brush were caressing a leaf into being as Giuditta watched. Within the outline of a small leaf, the brush spread a layer of yellow green, then touched the palette and returned with a darker green that covered everything

except the curving top of the leaf. Again, moving with tender certainty, the brush stroked bright yellow on one side of the leaf and paused.

He stopped and took a step backward, regarding the wet blaze of color. He bent forward again, and the brush drew a thin line of shadow on the leaf's underside and lifted it away from the surface of the wall.

He had been absent from the palazzo since the day of Emilia's death, and it was only a few moments ago, when Giuditta came out of her room and looked down into the courtyard and saw the pigment tray and a pile of paint-smeared rags, that she realized he was back.

She waited a short while longer, hoping he would turn and speak to her. The brush began another leaf; she sighed and crossed the courtyard toward the kitchen.

White curls were floating in the air near Clarice and Lucia, who giggled as they plucked the chickens for dinner.

"Clarice, did you shell the beans?"

Clarice looked up, open-mouthed, thin fingers plucking at air.

"Lucia, I want mint, oregano and parsley from the garden. Remember to sweep up when you are finished."

She diced pancetta and tumbled it into the fava beans in their clay casserole; slipped the purple garlic cloves from their skins and tossed them in as well; added a little water and carried the casserole to the oven.

"Clarice, watch until they are tender, then a little olive oil and oregano, and you can take it out. Lucia...."

Lucia smiled, plump-cheeked, her head tilted expectantly.

"Cut up the chickens and leave the entrails for Lorenzo, but put the pancetta away, he is not permitted to have that."

So it would be two more hours before she started the chicken, and now, remembering Alessandro, she laid stalks of white asparagus sprinkled with olive oil and lemon on a plate, and added slices of salami and olive bread.

Carrying the plate into the courtyard, she saw Alessandro

look over his shoulder at her. He laid his brush and palette down and wiped his hands on a rag as she came toward him, one leg extended slightly, like the statue of David, the beautiful bronze boy.

"Where have you been?"

"I was ill with a fever on the day Signora Emilia died." A flash of white biting an asparagus tip.

"I was told of her death. After I was better, I waited until the Signora sent for me."

He sat down on one of the stone benches under the arcade, and she sat beside him and watched him eat.

"I was told they arrested the sister-in-law for murder."

"What else do you know?"

He bit off an asparagus tip. "People ask me, I tell them I know nothing."

"She—Emilia—was found out there, in the garden. Antonia found her. There was a broken statue, the foot was broken, I saw it myself a few days before. Someone struck her on the back of the head with it. Ottavio found a necklace next to the body, and everyone thought it was Bella's, and the next day she was arrested and taken to Pagliazza. But I know she is innocent." She felt a dappling of sweat on her forehead, warmth creeping into her cheeks. He was staring at her intently.

A pair of heels clattered down the staircase; Laura teetered on the last step and peered at them with mournful eyes, then stepped into the courtyard.

"Which one is that?" he asked.

"Laura. It is her mother who is in prison."

"Papa!" Laura cried and darted across the courtyard as Domenico came through the entryway. She stood on tiptoe to embrace him, her dark brown hair only a shade lighter than the black satin of his embroidered doublet. He pressed his cheek against the top of her head.

"Did you see her?"

Giuditta stood up and moved closer to them.

"Yes, I saw Mama." He spoke slowly, as if he were sleepy with wine.

"She is alone in her own cell...."

Laura twisted away from him.

"When is she coming home? Did you ask them?"

He looked down at her with heavy-lidded dark eyes the same almond shape as her own, looked without answering until she stepped back and stamped her foot.

"Not until after the trial," he said in the same drawling tone.

"Have you seen your grandmother?" He started toward the stairway.

"Is she in her apartment?"

After her father left, Laura trudged over to the opposite stairway and sat on the bottom step, biting a fingernail.

Silently Giuditta picked up Alessandro's plate and carried it back to the kitchen, where the aroma of simmering beans and bacon greeted her. She picked up a sieve, laid it over a large casserole and began crushing sour green grapes through the holes. She took the pancetta out of the cabinet and diced it with quick angry strokes—anger at Domenico and his indifference to Bella, as if she were a guest at a country villa instead of a prisoner of the Florentine republic.

When she finished the bacon, she began chopping the parsley and mint, and it was not until she was frying the chicken over the fire and watching the skin turn tawny gold that her anger began to soften just enough to let her thoughts return to the delectable Alessandro.

eight

THE COLOR OF HER EYES REMINDED HIM of leaves in autumn, light brown layered over gold, and that was the way he would paint her, beginning with warm tones, modeling with darker hues, making her russet hair sparkle with gold highlights. A green dress, the color of the sliced melon she sometimes brought him, with a white crescent of chemise showing.

If she were rich, she could commission him to paint her portrait, although the rich, more often than not, were pale and wrinkled like Signora Novella. But Giuditta was not rich, and he was so poor he had no time to paint unless someone paid him. He had made a few sketches, from memory, of her face, and he kept her image in his mind along with all the others he had collected in his lifetime.

Someday, when he earned as much money as his maestro, he would paint Giuditta for himself.

He heard the door to the staff dining room close, and he turned to watch her coming toward him with the plate balanced on her arm, the wine bottle dangling from her left hand. Ghirlandaio. She smiled, extending the plate of cold chicken, and

he inhaled the fragrance of grape, mint and bacon. He took the plate from her.

"I have something to show you. In private. It concerns Signor Domenico."

She frowned and moved back a step, glancing around the courtyard.

He picked up a slice of chicken and bit into it. She watched him eat, and her watching made him utter little grunts and sighs of appreciation. When he finished, swabbing the plate clean with bread, she said, "Can you come at midnight? The side door on Borgo degli Albizzi. I will meet you there."

Her skin still felt sticky from the day's heat as she lay on the bed in her shift, the soles of her feet pointed toward the open windows. Beyond them, the midnight sky lengthened like a wall hanging of indigo silk. Sometimes a current of cool air would start there, moving along her legs and arms, and she would sigh with pleasure as it grazed her neck and face.

Curled beside her, Lorenzo slept.

Around midnight she rose, slipped into her dress and sandals, picked up a portable candleholder and lit it from the taper fluttering on the small table near the window. When she opened the door, four cat paws thudded softly against the floor, and he rubbed against her ankle as she stood in the open doorway.

"Go on, go on, I do not want you weaving in front of me and making me trip over you." Listening to the click of his nails proceeding along the passageway, she followed him to the loggia, then turned left until she reached the back passageway. The old hinges squealed as she pushed open the door, faintly stirring the stagnant air of the corridor.

At the end of it, she descended the stairs to the store room and unbolted the door. She opened it an arm's length and held the candle up before her.

A dark figure stepped into the circle of light, and she saw it was Alessandro, carrying something under his arm.

In her chamber, she closed the door quietly behind him and

lit three more candles: cones of light curved against the walls,
leaving the ceiling and floor in shadow. She watched him study-
ing the simple room—the disheveled trestle bed, the table and its
two rush-bottomed chairs, the large unadorned chest at the foot
of the bed. When he had satisfied himself looking, he laid the
object he had been carrying on the table.

"Whose is this?"

"Mine. My sketch book." His fingers tapped the leather
cover lightly.

"Yesterday I finished early, in midafternoon, and I went
through the garden to the stable yard on my way home. When I
came out onto the street, I saw Signor Domenico ahead of me
on horseback.

"I followed him toward the river, because I was going that
way. Then I followed him across Ponte alla Carraia, through
Porta Romana to a villa in the middle of some fields. He
untacked the horse and left it in the field while he let himself in
through a door in the garden wall.

"I saw an old fig tree near the wall. It had heavy branches,
the kind that stretch out. I climbed up and looked down into the
garden."

The leather cover creaked as he opened the book, turning
the vellum pages until he reached the middle; he held the book
flat against the table, and she leaned toward the hovering flame
and the circle of lemony radiance spreading over the page.

The first sketch showed a man and a woman: she was lean-
ing backwards over his arm, her arms circling his neck as his
mouth fastened to hers. In only a few lines, Alessandro had cap-
tured the peculiar roundness of Domenico's head, the meaty
hunch of his shoulders, his thick hands.

A flush crept up her neck and into her cheeks, but she kept
her glance down, focused on the page.

In the second sketch, the woman was standing up, and
Domenico's stubby fingers clasped her breasts.

Disgust uncurled in the pit of her stomach.

"Is there more?"

"One more." He turned the page: the same pose, except now her hands clasped Domenico's buttocks.

"Then they went into the house, and I went home and made these sketches. Yesterday, when I heard him speak to his daughter, I thought 'This man does not care that his wife is lying in a stinking prison,' and that is why I followed him."

"This mistress, whoever she is, is not the first. Bella knew about the others."

"See, Giuditta, he is clever. He killed Emilia so his wife would go to prison. Instead of killing his wife."

"No," she said quietly, "I know that someone was paid to kill Emilia and leave Bella's necklace there. I know who the assassin is, but I do not know who paid him."

She began turning the pages backwards, slowly.

"Bella's absence does not displease him, it is convenient for him." The pages were filled with sketches of the most ordinary things—hands, a velvet hat on a young man's head, a horse's head and arched neck.

"Who is this?"

He smiled shyly, tracing the sketch with his forefinger.

"Do you not recognize yourself? I made sketches from memory. For your portrait."

"I could never pay you for a portrait, I earn so little, I have so little saved."

She felt his fingers lift a lock of her hair and hold it out toward the light.

"The color is so beautiful, there are so many reds in it."

His mouth was formed like those of the angels on altarpieces and frescoes, and she let herself imagine how its angelic shape might feel if she kissed him.

"I am such a poor man I cannot afford to paint anyone who cannot pay me. But one day, if I become as rich as Maestro Sandro, with commissions and my own workshop...."

An imperious wail pierced the early morning stillness, then a succession of shrill cries just outside the door.

"It is Lorenzo. I have to let him in or he will scream all night."

She hurried toward the door and opened it narrowly. Lorenzo swaggered inside.

"*Geloso.*" He bent down and stroked the cat's back.

This time she closed the door behind her so the cat would stay inside while she led Alessandro to the side door. As he stepped outside, her candle surrounded him briefly with a vault of light before he stepped back into darkness, and she listened to his light footsteps echoing between the buildings until she could hear them no more.

She closed the door and locked it, and as she was lifting the bolt into place, she heard rapid footsteps coming down the staircase.

She pulled back into a corner of the store room and waited.

A moment later, just as the pointed toe of a man's leather boot appeared on the stairway, she remembered to blow out her candle.

nine

AFTER WE ARE MARRIED, YOU WILL NEVER have to leave me." Antonia kissed the rough suntanned skin on the back of Simone's neck as he sat on the bedchest pulling on his boots.

"When are you going to ask your father?"

She hopped off the bed and slid her feet into a pair of red slippers.

"I am not going to ask him. I am going to ask my grandmother instead because she always tells my father what to do. It made my mother furious. She used to tell him he should be in charge of the business instead of Grandmother."

"What about your grandfather?"

"No one pays any attention to him. He is only interested in his antiquities and his library. Grandmother is in charge of everything." She lifted the lantern, and he followed her silently through the dark *anticamera* and the door leading to the loggia. Moving cautiously along the wall, they reached the passageway outside Laura's room which led to the back stairs; she always felt safer once they were encapsulated in the musty darkness, even though the floorboards creaked beneath their feet.

She handed him the lantern to carry going down the stairs; with the side door open, she kissed him goodnight, then he handed the lantern back to her, and she closed the door and locked it. With her fingers still touching the key, she heard a noise behind her; she jumped, and the lantern light dipped as she whirled around to confront whatever it was.

She saw a hand framed in the lantern's reddish glow, and she immediately recognized its broad shape and the long square fingers that could curve around an axe handle and mercilessly escort chickens out of this world.

"Giuditta?"

The cook stepped forward holding a smoking candle.

"What did you see?" Antonia said.

"Whatever I saw I have already forgotten."

"Good. Keep forgetting."

Giuditta yawned.

"Why are you here? Did you just come in?"

"I had a guest. "

"Veronica?"

"No."

"Who?"

"I am sleepy. Lend me some flame for my candle."

That night, in her dream, Giuditta was seated at one of the long work tables in the kitchen. On the table stood an earthenware bowl filled with fresh country strawberries, and they were hers alone to eat. She picked one up and bit into its fragrant flesh, and her mouth became awash with such intense sweetness that she closed her eyes and moaned with pleasure. She had just selected a second gleaming berry when Ottavio stepped into the kitchen, scowling, snatched the bowl off the table and carried it away.

Her favorite part of the day was midmorning, when she stepped out onto via del Proconsolo with her basket on her arm, and Lucia and Clarice following her. At that hour, the day was still young, past its first youth perhaps, but still more young than old,

still filled with promise and possibility. To get out beyond the kitchen walls at least once a day and watch the life of the city was as necessary as breathing.

She followed the same route every day, down via Dante Alighieri to via dei Pittori, then right to the street of the apothecaries and herb sellers, where she often stopped to buy cinnamon and nutmeg, cloves, saffron or ginger.

This street, via degli Speziali, worked like an appetizer, increasing her attentiveness as she neared Mercato Vecchio, where a brocade of aromas surrounded her as she moved among the stalls and began envisioning the evening meal.

Today, at the fish seller's, she bought sole; in the afternoon, the fish bones and heads would simmer in wine with rosemary, ginger and the juice of bitter oranges. Rosemary grew in the garden, and she had ginger in the cupboard, but there were no oranges left. She strolled away from the fish seller's stall toward the row of vegetable and fruit stalls on the edge of the square, with the two maids chattering behind her.

A green-liveried herald on horseback stopped at the edge of the square to shout the name of someone sentenced to die.

A blind beggar thrust his bowl toward her, and she dropped a few coins in it.

She walked around two dogs snarling over the bloody entrails of some animal and stopped at a table laden with opulent green melons, dark green patterned with ochre. Two would be enough for Clarice to carry. The small bitter oranges radiant in their basket, she needed only a few of those, then she moved on, her gaze fondling the plums and peaches, the sparkling berries. She bought plums and waited in the crowd of women buying spinach. In a sauce of sauteed pine nuts, dried fruit, balsamic vinegar and cinnamon, it would go well with the poached sole.

She had her design now, like Alessandro's sketches, the basis of a beautiful meal; a meal that without Bella's presence would be eaten but not savored or remembered.

At the palazzo, she sent Clarice and Lucia to the kitchen to begin cleaning the fish while she stopped to watch Alessandro.

His back was facing her as he painted, one leg extended so it stretched the fabric of his grey hose tightly across his buttocks. Like a melon's curve.

"Giuditta! Here, look up."

Laura peered down at her from the loggia.

"Throw a plum up here."

She picked one up, juggled it in her palm, then laid it back in the basket.

"Come down here, and I will give you one."

Laura pulled away from the railing, and she heard the girl's heels clacking along the tile and down the staircase.

Alessandro glanced at her over his shoulder.

"How is your cat?"

"Lorenzo?"

"*Geloso.* You should name him *geloso.*"

"You misunderstand him. He is not jealous, but he does claim certain privileges—entrails, fish heads, and the safety of my bed. As long as he has those, he is content."

He smiled, his lower lip quivered as if it might shape a word, and she watched his eyes as he considered it and finally chose to remain silent.

Laura was beside her now, her smooth little hand closing around a plum.

"What are you making for dinner, Giuditta? Remember how my mother used to ask you that?" Laura's eyes, which were usually bright with amusement, had become stunned and sorrowful since Bella's arrest.

"Have you seen your mother?"

"I went yesterday with my father. She misses us, she misses you...."

"Yes," Giuditta said, "it makes me heartsick to think—" A flash of scarlet caught her eye as Angelo swaggered through the entryway and stopped under one of the arches. Today he was wearing blue hose above his tawny boots, a doublet of red satin, and a velvet hat of the same color, its curved brim flaunting a peacock feather.

"Why is he here?" Giuditta whispered.

"Why are you whispering? Grandmother wants us to have our lessons again."

He moved toward them with his familiar gait, his head thrust forward and his shoulders hunched, but today his posture seemed something more than odd.

Today it seemed menacing.

His thin lips mimicked a smile.

"Good day, Signorina Laura."

Giuditta took a step backwards.

"How fortunate you are to have a servant with such loyalty in her heart that she believes in your mother's innocence, although no one else—"

"Because she is unjustly accused!"

"And she expects that assertion to free Signora Bella?"

"I know nothing more than that," Giuditta said, "but I am surprised that a musician as talented as you are said to be would concern himself with speculation about a vile murder. It is a subject more suited to servants' gossip."

He listened with his arms crossed and his mouth tightened into a thin, appraising furrow.

"Or perhaps among coachmen in a tavern," she added.

He scratched the back of his head and stared at her, a chill emptiness in his eyes. How easily one of those supple hands could have closed around the marble foot and struck Emilia with no more emotion than she herself might feel for a handful of almonds ground in a mortar.

Suddenly there was a commotion in the center of the courtyard, birds screeching, wings flapping; Lorenzo skidded to a stop as a cloud of sparrows rose into the air.

"Lorenzo!" Laura giggled as the cat turned his green crystalline gaze toward her.

He lowered his head and came toward Giuditta with a panther's sinuous stride and wound his tail around her ankle.

"Come, Lorenzo." She lifted him up with her free arm. "Come see the beautiful fish heads in the kitchen."

———

On some nights Lorenzo stayed out all night, and she had to fall asleep without him curved soothingly beside her, but on most nights he was at her door by midnight to follow her back to bed, where he kneaded the straw mattress for a long time before curling against her side with a loud, throbbing purr. Tranquility flowed from his presence beside her, something beyond explanation, and within this soothing nimbus she had time to think over the day's events, like today's encounter with Angelo Villani. It had been cunning of him to address Laura, who might have revealed something by accident; and although he made her shiver with revulsion, it was fortunate that he would again be coming every week, giving her a chance to watch him....

She rested her hand on Lorenzo's warm flank and felt him stretch and turn his downy belly against her thigh.

A few moments later, she was asleep.

ten

SUNDAY WAS GIUDITTA'S DAY OFF.

In the morning, she and Veronica always attended mass at Santa Maria dei Fiore and usually left the cathedral when the service was over. But this morning they stayed a while longer because Giuditta wanted to go into the Sacristy to look at Donatello's beautiful marble choir stall: she knew each playing, singing, dancing cherub by heart, and the sight of them was an ever renewable delight.

Veronica waited patiently, hands clasped in front of her, until her friend was ready to leave; they strolled through the crowd in Piazza San Giovanni and continued toward the river.

The heat dabbed tiny beads on Veronica's brow and upper lip, and a few tendrils of hair stuck to her brow. The two women walked down via Calimala in silence as if neither of them wished to disturb the late sleepers lying behind closed shutters.

"You are never quiet this long on a Sunday morning," Veronica said.

"How can I enjoy this day," she made a sweeping gesture toward the sky, "when poor Bella is in prison?"

They crossed Por Santa Maria onto the Ponte Vecchio.

"But the family must have contacted the magistrate to have the charge dismissed, as other prominent families do. Or have they petitioned the Signoria?"

"They have not done anything. Someone in the family wants her to be found guilty."

"Even Domenico?"

Disgust soured her mouth.

"Him! It makes no difference to him. Apparently he has a new mistress to occupy his time."

They reached the small piazza in the middle of the bridge, with its view of the rowboats gliding across the river, the new palazzi on the south bank, and the jagged line of the *colli* beyond.

"The family has treated me well all the years I have worked for them, but I have seen how they use people. They needed Bella and Emilia to produce heirs for the business, and now that they think Bella is no more use to them, they are content to leave her in prison."

Veronica sighed and folded her arms across her waist.

"And one of them is capable of hiring Angelo to kill Emilia and let Bella be put to death for it."

In cooler weather, spring or early fall, they would have continued across the bridge and up into the *colli* for a view of the city, but the heat was increasing even near the river; they left the bridge and each returned home to sleep.

In her room, where the closed shutters battled against the sultry heat, a wedge of brightness pushed the darkness apart near the doorway, leaving the rest of the room so dense with shadow that she almost tripped over the soft dark form lying near the bed.

She nudged it gently with the toe of her shoe; it swayed and fell back, a dead weight. Stepping around it carefully, she went over to the windows and pushed open the shutters: brilliant golden light spilled into the room.

She identified it from where she stood, only a small dead bird lying on its side, a dull bead for an eye, small wings stiffening, feet cramped into claws.

"Lorenzo! Where are you, you treacherous scoundrel?"

She glanced around the room without seeing him. In the past, he had always carried his half-dead birds into the kitchen to torment them until they died in a tangle of blood and feathers. But here, beside the bed, she saw no signs of a death struggle, and the bird appeared unscathed. It was only when she knelt down beside it and saw what looked like a thin wire trailing from a loop around its neck—it looked like a string from an instrument—did she remember that Lorenzo, for all his wiliness, did not know how to open a door.

A little chill writhed up her back and down her arms as she picked up the bird and held it in her palm, staring at its slender noose.

Then she carried it over to the window and dropped it into the street.

The single window in Bella's cell was a high, thin rectangle beyond which dangled a ribbon of sky. This morning, Sunday, it was deep aquamarine, shining like glazed terra cotta, the only element of beauty in her dreary cell.

Every morning she turned her back to the window and let its light fall on the hand mirror Laura had brought her as she combed her hair. Every day the combing was harder as her hair became more greasy and matted, but when she was free, she would bathe with rose petals, wash her hair with a lemon rinse, and rub almond oil cream all over her skin. She would be able to breathe deeply without inhaling the vile prison stench; on the terrace, the fragrance of lemons would saturate the mild summer air....

And yet: when he came to visit her again, two days ago, she discovered he had still made no attempt to free her.

"The family must act together. I cannot do anything until I speak to Caterina."

"No," she said, "you are lying. You mean to leave me here because it is convenient for you."

"How can you make such an accusation? Our family is dishonored as long as you are imprisoned."

Then she turned her back to him and stared up at the window until she heard his crunching footsteps and the groan of the cell door as it closed behind him.

eleven

O N FRIDAY AFTER THE MORNING MEAL, Antonia hurried out of the dining room without any one remarking on it, as Emilia would have done, hastened upstairs and through the loggia until she was outside Caterina's apartment. From this perspective she could see half of the arched entryway and the adjoining arcade. When the visitor stepped into the courtyard, she would have a full view of her before she ascended to the *piano nobile*, and if she happened to be sitting in the loggia with the embroidery frame before her, or one of Emilia's books, such as *The Life of St. Francis*, open in her lap, she could look up demurely at the sound of the porter's footsteps and get another look at the visitor as she was escorted into Caterina's *anticamera*.

A book would be better, more portable, although if she had to wait a long time, it would be better to leave St. Francis on the shelf and pick out one of the romances Emilia used to read so avidly. The romances were not displayed on the carved walnut shelf beside St. Francis but were concealed in one of the bedchests, the one nearest the headboard on the right. They should still be there, along with all her dresses and shoes and jewelry, just as they were the day she died.

"The day she died," she said out loud, and even after she said it, she felt nothing, not a trace of sadness at Emilia's absence.

In the herb garden, the afternoon sun draped a collar of warmth across Giuditta's neck as she leaned over sprigs of marjoram, mint, basil and parsley. She stood up, inhaling their mingled fragrance and the farther scent of the lemon trees; no fragrance was lovelier, not even the expensive musky perfumes rich women anointed themselves with.

The fragrant air was seductive this afternoon, inviting her to lie drowsily in the grass instead of going back to the kitchen to make a sauce—wine, olive oil, vinegar, nutmeg, cloves and the juice of bitter oranges—for the salt cod.

The kitchen door swung open behind her, and Ottavio came out, blinking in the sunlight. He came toward her with measured steps, as formal and controlled as always, hands clasped in front of him, and a wisp of smile on his lips.

So he was going to ask her to do something.

"The Signora has a visitor, and she asked that some light refreshment be brought to the *anticamera*."

"Who is it?"

He followed her into the cool kitchen, where Lucia was cleaning the fish, and Lorenzo sat patiently at her feet staring at her.

"A Signora del Marco." Giuditta placed two glasses on an embossed silver tray and poured wine into a blue flask.

"Who is she?"

"She is said to be a marriage broker." His eyes widened and a close-mouthed smile creased his face.

She took a melon out of the pantry and sliced it and laid the slender green crescents on a plate. Beside them, alternating in precise rows, she arranged almond cookies and tiny plum tarts.

The glasses trembled as she crossed the courtyard and ascended the stairway to the loggia, composing her features into a copy of Ottavio's discreet immobility. She knocked on the door and waited for the Signora's answer, then nudged the door open

and found the Signora and her visitor sitting stiffly erect in two
armchairs on opposite sides of a small, linen-draped table.

"Please."

She rested the tray on the table and began laying out the plates
and engraved silver forks and the embroidered linen napkins.
Signora del Marco was about Bella's age, with abundant chestnut
hair and wintry grey eyes beneath delicately plucked brows. She
had paused when Giuditta came in, and now she leaned forward
expectantly as the cook offered her the plate of pastries.

They would smile and not say anything as long as she was
there, and she could not linger as she did in the dining room,
where the *signori* acted as if the servants were blind and deaf.

Pouring the wine, she glanced at Caterina's face, which was
as inscrutable as ever. The marble matriarch.

"Thank you, Giuditta."

She closed the door gently behind her and started back to-
ward the staircase.

"Giuditta!" A loud whisper sailed after her. She turned
around; Antonia was seated near the balustrade with an open
book on her lap, jiggling impatiently in her chair.

"Did you hear anything? What were they saying?"

"Nothing. They did not speak while I was there."

Antonia tugged at the cook's apron.

"They were not speaking to each other? Have they quar-
reled?"

"They seemed on good terms with each other, but they did
not say anything I could overhear and repeat to you. They were
waiting for me to leave."

"How do you know?"

"How?" She tugged the apron away.

"I have lived twenty years with this family. I know."

That evening Lorenzo, heavy and sated with fish tidbits, followed
Giuditta to her room and settled himself in a furry coil on top of
the bed while she leaned against the window looking at Il
Duomo.

Just now, with the air growing cooler, a slight breeze grazed her face and arms. The heat of July and August was detestable, but the air in the evening was cool and languorous, like a delicate sauce for the skin.

Twenty years had passed since her parents had died, and the tenancy of the farm passed to her uncle and his sharp-tongued wife. One summer morning in her twelfth year, she simply walked away, took the road to Prato and followed a farmer's cart through the city gate to Mercato Vecchio. The void in her stomach made loud grumbling noises as it enlarged; a basket of blushing peaches tempted her, and she decided to steal two while the fruit seller was helping someone else. As her hand darted forward and closed on a peach, a woman's rough-skinned hand grabbed her wrist and held it.

She looked up into a stern Florentine face. All of the elements of this face—brow, nose, mouth—were coarsely drawn, deep lines were incised on the tawny skin near the eyes and mouth, and the eyebrows were dark furrows, heavy and intimidating.

"I will buy you the peaches," Filomena said, and then she asked her name, and where she was from, and who her parents were. It ended with Giuditta carrying the old cook's baskets back to the palazzo, scrubbing the kitchen floor, and washing the dinner dishes that night.

Energetic and wise, Filomena had taught her all she knew about cooking and much of what she knew about human behavior. The village where she lived with her nephew and his family was close by, an easy walk on a Sunday afternoon, yet five years had gone by since Giuditta last visited her. By now, Filomena was well above seventy, it would be foolish to let another year go by without seeing her.... She would go at the end of summer, early in September, when the weather was cooler.

As she moved away from the window, Lorenzo suddenly sat up in the middle of the bed, muscles tensed, ears pointed forward; even the transparent green globes of his eyes seemed to strain forward. From his throat came a low growl.

She froze, staring at the door, which was locked and bolted. She heard nothing except the beat of her own pulse, but she sensed a listening presence on the other side of the door.

Listening for her.

The mattress creaked as Lorenzo jumped to the floor, back hairs raised, and growled again.

Outside a footstep sounded, and another. Then quiet.

Lorenzo padded back to his warm hollow in the bed, curled up with his head resting on one outstretched front leg and looked up at her.

"So," she said, "do you think it is safe to come to bed?"

twelve

"TASTE THIS," VERONICA SAID, HOLDING out a spoonful of raspberry cream. Giuditta swallowed it slowly, eyes half-closed as if she were listening to angels sing.

"Perfect."

"Not too tart?"

"Exactly right. Balanced."

"They did not eat much of it at dinner, so I wondered."

Giuditta waved one hand dismissively.

"It is almost too hot to eat. Try it again when the weather is cooler."

The air in the Alberti kitchen was moist and warm, even at eight in the evening with the door and both windows open to catch any breath of air.

"As I was saying, Antonia begged me to tell her what they were saying, although I overheard nothing. They stopped talking when I came in, so it was clear...."

"Sometimes they remember we have ears."

They were sitting across from each other at a long pine table with a flask of vin santo and a single candle between them.

"It seems that Signora Caterina would not be opposed to an alliance with this family. If it is arranged, Antonia will have what Emilia would have denied her."

"I have heard that years ago the two families made arrangements to be united, but the marriage never took place." Veronica took a sip of wine, holding the glass between her palms.

"Signora Caterina?"

"No. A younger brother, Rinaldo. He was to marry Simone's aunt, Beatrice, but he died suddenly just before the wedding."

"Rinaldo? I have never heard of him before." She pressed her hands flat on the table, fingers outspread.

"I always believed the Signora was Signor Filippo's only child. Filomena said he was very proud of her aptitude for business."

Both fell silent for a time. Candlelight flickered in the crimson depths of the wine; water dripped into a stone sink, and a mosquito circled a bowl of fruit on the table.

"Giuditta." Veronica touched the back of her hand lightly.

"I have been thinking about pumpkin tortelloni. What do you think of adding ground almonds to the pumpkin, and a little mustard?"

"Mustard?" She ran her tongue over her lower lip.

"If it is not too heavy. It should be like a painting of a peach, mostly pink or yellow with an accent of red." She glanced out the door at the darkening sky.

"Where did the time go? I have to go, it is close to curfew."

The flambeaux were already blazing outside the palazzi as she hurried through Piazza Santa Croce to via Torta, where the houses rose in narrow black rectangles against the sky.

She passed someone sleeping in a doorway in via del Anguillara, then she crossed Piazza di San Firenze and went north along via del Proconsolo. Something, some thought, had followed her all the way home, tugging at her the way Antonia had pulled at her apron.

In the shadowy corridor leading to her room, Lorenzo brushed against her legs as she unlocked the door; he bounded

ahead of her and jumped onto the window sill to look out at the night. Motionless he sat for several minutes, profiled against the sky, then turned his head slightly, following his cocked ears.

Giuditta stepped out of her shoes, locked and bolted the door and took off her dress and chemise. She lay down on the bed and, closing her eyes, saw the image of Antonia outside Caterina's apartment, jiggling impatiently. The girl was so close now to what Emilia would have denied her.

Was it possible that Antonia borrowed Bella's necklace and gave it to Simone to have copied? Then Simone could have given the copy to Angelo to leave when he killed Emilia. Perhaps they could not have planned the day or the time of her murder for it was a matter of opportunity—but they must have believed Angelo's presence in the palazzo on any day beside Wednesday would not be questioned.

They did not imagine that Giuditta would see Angelo on the day Emilia was killed and remember it.

She turned on her side and sighed. A moment later something thumped against the mattress, and Lorenzo's fur brushed against the back of her legs. She listened to the rrft rrft his nails made as he kneaded the mattress, then he fitted his back neatly within the angle of her thigh and calf and lay comfortably still.

thirteen

THE FOLLOWING MONDAY, THE FAMILY of Antonia Novella agreed to her marriage to Simone Alberti with a dowry of one thousand florins to be paid in the following manner: half in money and gifts, and half from the Novella family's investment in the dowry fund.

"The Signora has invited them to dine here a week from Saturday," Ottavio said. He was standing next to one of the long work tables, watching Giuditta's fingers scoop a well in a mound of flour.

She broke an egg into the center of the well, then two more and began beating them with a fork.

"Signora Emilia would not have been pleased with this alliance." The fork moved deftly, blending egg yolk and white.

Ottavio brushed flour dust off his black doublet.

"Everyone knew her opposition. Her opinions were never secret."

"No one seems to miss her or her opinions now. Not Antonia." She guided flour in small increments into the eggs, stiffening them.

"Antonia's wish is fulfilled. It would be unnatural not to be cheerful."

She swept the rest of the flour over the egg mixture and began working it with both hands.

"She should be, with everything happening as she arranged it."

"Hoped for, you mean."

"More than hoped for." She straightened up, wiping her forehead with the back of her hand.

"There is no mistake about Bella," he said. "I saw the necklace myself."

She gave him a long, unwavering look.

"The necklace does not prove anything. She might have lost it earlier walking in the garden."

He watched her scrape sticky remnants of dough off the table. Of all the servants in the palazzo, it was Giuditta he knew best and respected the most: with her he never used the curt, commanding tone he applied to the others. And suddenly, from one day to the next, when she had accidentally discovered his secret, he learned that he could trust her. Had to trust her.

"Giuditta!" Antonia bounced down the three steps into the kitchen.

"Are you planning the banquet yet?"

She turned away from the sink, drying her hands on her apron.

"Not yet."

"Are you happpy that I am going to marry Simone?"

"I am flattered that you seek my opinion," she said, folding the dough over and pushing it away with her palm.

"My mother would have disapproved."

The lightness in her voice startled Ottavio, although it should have been no surprise. Antonia and her mother had argued so often during the past few years that the clamor of their verbal brawling had become one of the most familiar sounds of daily life in Palazzo Novella. One might almost conclude that the girl was more relieved than grief-stricken by Emilia's death.

"I know. I heard you arguing...."

"I argued with her almost every day, and now that I am to

marry Simone, we still have to wait until after Bella's trial." Her lip quivered petulantly.

"When is it?"

"What sauce are you making?"

"Garlic sauce with walnuts." She passed Antonia a bowl of walnuts and a nutcracker. The girl cracked one and stuffed the nutmeat into her mouth.

"When is the trial?"

"No one knows yet," she mumbled. "Grandmother is going to find out."

When she finished chewing, Ottavio said, "Who is the magistrate?"

"Grandmother said it is someone from Pistoia." She reached for another nut.

"Are you going to shell those for me or eat them?"

"Shell but not grind in the mortar."

"You should learn how to cook."

"Ha!" She shook her head, tossing the walnut in the air.

"Why should I? The Albertis have your friend Veronica as cook."

"Yes, their cook is my friend, and she is highly accomplished." She picked up a garlic clove and began peeling it.

"And when you move to Palazzo Alberti, Veronica will tell me what you are doing and how you are behaving, and it will be as if you never left."

fourteen

A LESSANDRO NEVER WENT TO MASS ON Sunday, never saw the inside of a church unless it had frescoes he wanted to see—instead he tried to escape from the tumult and racket of six younger siblings by walking uphill behind Luca Pitti's extravagant new palazzo until he found a satisfying view of the city.

Now, seated on the yellowing grass, he was sketching the stone towers of Florence, the rippled carpet of vermilion roof tiles, the green river winding under its four bridges, and the blue *colli* beyond. Surrounded by the fragrance of pines and the sleepy buzzing of insects, he was content, and as he began to draw the robust arc of Brunelleschi's dome, it reminded him of the shape of a basket held against Giuditta's hip, of the enticing curves of her shoulder and neck.

During the week, when he was working on the fresco, he looked forward to midday, the sound of the door swinging open behind him, her footsteps light and swift crossing the courtyard, and the way she watched him while he ate, as if she wanted to eat *him*.

He did not mean to ignore her, if that was how it appeared, but he did not have time to talk while the day's section of plaster

was still wet. Perhaps it was not clear to her how the painting must be done, but he could make that plain to her tomorrow, after he was finished for the day. He would go into the kitchen, and she would smile—her teeth were lustrous—and invite him to sit at one of the pine tables with a glass of wine. He would linger, watching her work, telling her about the long hours of his apprenticeship in Santa Maria del Carmine and Santa Maria Novella. And he would begin telling her how he worked, holding all the colors and intensities in his mind, balancing and adjusting them to reach a perfect harmony, and how it was all so fragile that he was constantly afraid it might slip away before the paint glided onto the wall.

Every Sunday since his wife's death, Carlo had attended services at Santa Croce with his parents and his daughter.

Afterwards he went alone to the Baptistery to sit under the great vault and look up at the giant figure of Christ welcoming the souls of the Blessed: surely Emilia, who had been spoken of as one the most pious women in the city, was among them.

Lately, however, his glance had strayed beyond the left hand of the Savior toward the horned, clawed demons of Hell devouring the souls of the damned. Not that he wished that for her, but he could still remember the lash of her sharp tongue, her quickness to judge, her slanderous insults.

Perhaps she would have been less quarrelsome if they had moved out of the palazzo, as she had often urged. He had refused, making up reasons, when the real reason, as Emilia once screamed at him, was his fear of displeasing Caterina.

"A grown man, afraid of his mother!" she jeered. At the meal that evening, she glared at him but remained silent.

And now she would remain silent for the rest of his life.

Domenico's arm felt numb, but he dared not move it while Paola's head rested so peacefully on the cushion of his shoulder. She slept tucked up against him, one hand curled on his bare chest, her blonde hair unfurled across his upper arm.

The slenderness of Paola's arm, the fan of bones beneath the back of her hand, the small knobs at the wrist, always astonished him after his long familiarity with Bella's fleshy abundance. His gaze traveled toward the end of the bed, where a small carving of a woman, gilded from the top of her ringlets to the waves of her hem, rested high on the wall. The ringlets, with their dark blonde hue, were like Bella's springy curls; that hair, her pride, swarmed in dirty coils around her shoulders the last time he had visited her in prison. Again she demanded that he attempt to free her, and although she clearly was guilty of Emilia's murder, one could be certain she would not murder again. So he had gone to Caterina and expressed this belief and said they should use their influence to have the charge set aside.

"No," Caterina said with that flat, implacable tone that always irritated him.

"She is guilty, and she must be tried."

But Laura believed she would go free, and he never disagreed when she spoke this way; sometimes he even allowed himself to imagine Bella's return. Would she be angry with him and the family for failing to pressure the magistrate or petition the Signoria? Her anger was something he did not like to remember.

Better to look forward to the bath he and Paola would take after she awakened, and the light meal in the garden. Better to enjoy each moment as he lived it.

Laura clutched Giuditta's hand as the jailer lifted the bolt, and the heavy iron door swung open on shrieking hinges. In the cool, dark cell, a small figure separated itself from the shadows and came toward them.

"Mama!" Laura rushed toward Bella's open arms, but Giuditta remained just inside the doorway. Her glance moved across the dimness to a shaft of vibrant sunlight flaring through the narrow window onto the straw-covered floor. A thin straw mattress lay against one wall; a three-legged stool and a pail were the only other furnishings.

Laura and Bella were kneeling on the straw beneath the angled sunbeam, a transparent brush which painted half their faces in shadow, half in warm golden light. Bella cradled Laura's face in her hands, speaking rapidly, an agitated ribbon of words.

Bella's creamy skin had turned a dull doughy white; crescents of shadow rimmed her eyes, and her beautiful hair hung in jagged strands around her shoulders. The roundness of her cheeks and chin had vanished. Wrinkles ringed her throat and tugged at her mouth.

"Look." Bella gestured toward the mattress.

"Over there I still have the mirror and comb you brought me. But I have stopped looking in the mirror. Do you remember how I used to wash my hair every other day? Do you think they will let me wash it before the trial? What month did you say? What month is it now?"

"It is July, Mother." Laura rocked back on her heels. "Grandmother says the trial is in September."

"Caterina has not visited me once since I have been here. And Domenico used to come, and now he does not, and he has done nothing to free me." She lifted one hand up and Giuditta took it, a cold, dry-skinned little hand.

"God save you, Signora."

"What hope do you bring me?"

She dropped to the straw beside Bella and leaned close, speaking softly.

"After Emilia's death, a person who came and went freely in the palazzo boasted to a drinking companion that he had been paid to kill someone. I saw this person at the palazzo on the day of Emilia's death, and I made note of it because I usually saw him only on Wednesday. He always wore the same shabby hose and jacket, but a few weeks later I saw him with a fine set of new clothing."

"Angelo!" Laura cried. Her fingers flew up, covering her mouth.

"Yes, Angelo. I believe he was hired to kill Emilia and leave your necklace beside her so you would be arrested."

Bella gave a long, exhausted sigh.

"Who hired him?"

"That is still unknown to me."

"He stopped giving lessons after Aunt Emilia died, then he came back because Grandmother asked him," Laura said.

"Signora, no one saw Angelo kill Emilia, but I can prove that the necklace was left to incriminate you. I have something in my possession that can prove it."

"You will be free again, Mama! I will wash and comb your hair, and Giuditta...."

Bella nodded her head, wanly smiling.

"The guard.... He says you have to go now."

The three women stood up. Bella kissed Laura and stroked Giuditta's arm.

"You have given me hope, my dear friend, even if I must remain here until the trial."

Leaving the Pagliazza, Laura was silent, looking down at the paving stones as they walked, but at the corner of via del Corso she stopped and pulled Giuditta's sleeve.

"Can we not go just a little out of our way, through Piazza della Signoria or Piazza Santa Croce? The day is so fine, and I almost never go out unless I go to mass with Grandmother."

Farther along, near via del Proconsolo, a group of young men, resplendent in silk and velvet, moved down the middle of the street laughing and joking.

"The Piazza della Signoria is out of the way, and you can see Santa Croce when you go to mass."

"Sunday afternoon is the best time," she whined, and as the young men passed, heads turned and glances swept over her.

"Come on."

Laura stared after them.

"Signorina, I will not spend the rest of my day off watching you...."

She lagged sullenly a few steps behind until they reached the palazzo. Then she stopped.

"Why are you stopping now?"

"I have to stop when I think."

Giuditta crossed her arms and began tapping one foot on the paving stones.

"What if you come to Mama's trial, and no one will listen to you because you are only a servant?"

"You think they would be more likely to listen to a virtuous young lady of good family?"

"Yes, why do you doubt it? You must tell me everything you know."

"You know what I know."

"Not about the thing you have that will free Mama."

"That I will—" A carriage rolled by with a thumping clatter, "I will reveal to you later."

They passed through the entryway into the courtyard, and Giuditta started up the stairway. Laura followed her.

"I promise not to tell anyone."

"No! Not yet." They heard Lorenzo's angry "mrkgnao" inside the room as Giuditta unlocked the door and pushed it open.

Laura gasped.

Lorenzo glared at them from the middle of the bare mattress, which lay tilted half-way off the bed. The canvas sheets and the striped blanket lay crumpled on the floor. The pine chest at the foot of the bed was empty, and Giuditta's dresses, shawls and shoes lay scattered on the floor.

"Oh, Giuditta, why would a thief come to your room? You have nothing worth stealing."

Lorenzo bounded off the mattress and came over to Laura, rubbing against her leg.

"Do me the favor of closing the door, Signorina."

Her mirror had dropped to the floor but was not broken.

"Whoever came here did not come to steal. Whoever killed Emilia came here—"

"Looking for the object you spoke of."

Giuditta knelt down and picked up the brass pitcher.

"Did they find it?" Laura's voice shook, rising. "Did they find it?"

Giuditta picked the sheets up and tossed them onto the bed. "No, because I would not be foolish enough to keep it here."

That night, after the dinner dishes had been washed and returned to their shelves, and the two kitchen maids lay asleep in their small, airless room on the top floor of the palazzo, Giuditta glided silently down to the kitchen and picked up a fine boning knife which she carried back to her room and concealed in the narrow space between the mattress and the headboard of rush matting nailed to the wall.

fifteen

"T HE VINEGAR BOTTLE IS EMPTY," LUCIA trilled. She held the bottle between two small fingers curving like maccheroni.

Giuditta looked up from the stone mortar and the fragrance of ground cinnamon rising.

"It was half-full yesterday when I used it."

"Should I go to the cellar?"

"No, I will go."

A noise from Ottavio's office made her glance over her shoulder, and she saw Caterina coming through the doorway. Her movements were measured, sparing of energy.

"Good afternoon, Signora." She straightened up and laid the pestle down, folded her hands across her waist and feigned a smile.

"On Saturday, Giuditta, I expect about forty people."

"How many courses, Signora?"

"Three or four. There will be dancing between the courses."

"We could begin with salt herring in garlic and lemon. Artichokes in cream sauce."

"Is it too late for asparagus?"

"August...." She shook her head. "But if we can have fava beans from the estate, young and tender, I will cook them with bacon."

"Yes, with bacon."

"Chunks of Parmesan on vine leaves. And little chick pea tarts. For the second course, penne with sausage and broccoli."

"Good," Caterina said. She patted her white chignon with one bejewelled hand.

"For the fish, sturgeon in white sauce, baked trout, and grilled sole. Then spinach with dried fruit, anchovies and pine nuts, the way we are making it today."

"Then they will dance again." Her stubby fingers drummed heavily on the table.

"For the third course, if it pleases you, tortelloni filled with pumpkin, leeks in almond sauce, some stewed fennel. And duck breast in balsamic vinegar sauce. Is this sufficient, Signora?"

"It will give Enrico indigestion, but you can make it anyway. Zabaglione."

"And something not as rich, almond cookies and plum tarts." Bella's eyes would have shone with anticipation if she were there. "Do you wish anything more?"

"No, nothing more."

Lucia plopped the wet, towel-wrapped spinach leaves on the table and waited for Giuditta's instructions.

"Chop the herring this small, as small as your fingernail, and warm the pieces in a pan with a little oil."

Caterina moved languidly through the kitchen, looking at the hanging saucepans, the rows of plates and casseroles. She stopped near the tall pine cabinet where Giuditta kept the vinegars and spices and trailed her fingers across the wood.

"Laura told me you went with her to visit her mother yesterday."

"Signor Domenico asked if I would go with her. It was heartwrenching to see Signora Bella as she is now."

Lucia's knife blade whacked the cutting board.

"Criminals cannot expect to live in comfort."

"Pardon my forwardness, Signora. Our Florentine republic has not found Signora Bella guilty of any crime so far. I believe she has been falsely imprisoned and is suffering for a crime she did not commit."

"She has brought shame and dishonor to our family." Caterina's voice was cold, adamant.

"I hope she is found guilty and hanged."

Giuditta's neck and scalp felt prickly, her throat narrowed. She stared mutely at the Signora's eyes, the lids like little awnings over the rinsed-out blue. Angry words clamored to be heard, but she shut them in behind clamped lips.

Turning away from the Signora, she picked up the pestle and began grinding the cinnamon flakes again, and she did not look up until she heard Caterina leave.

Then she picked up the empty vinegar flask and strode through the servants' dining room into the courtyard, where two laundry women carrying clean towels and sheets were climbing the front stairway. Under the arcade, she saw the lithe curve of Alessandro's back and the brush moving in his hand.

She turned into the passageway leading from the courtyard to the garden: on the north side was the entrance to the cellar. She opened the door with her key and pushed it back against the rough stone wall, letting the light tumble down the dark staircase ahead of her. She started down slowly as the aroma of balsam wood, straw, and vinegar enveloped her like a comfortable old shawl.

On the last step, she stopped for a moment, waiting for her eyes to become accustomed to the dimness. Just before her loomed the stacked barrels of balsamic vinegar; against the farther wall stood casks of wine from the family's country estate.

She stepped down onto the straw-covered floor and moved slowly toward the vinegar barrels; the single shaft of light from the doorway was so weak she had to position the empty flask under the tap more by feel than by sight. She closed the tap, stoppered the bottle and licked a few drops of vinegar off her fingertips. The diced fruit soaked in the vinegar, with sauteed

pine nuts and herring added to the fresh spinach, was one of Filomena's best recipes.

She turned around and started back toward the staircase, but a patch of yellow straw fluttering with sunlight drew her into reverie, for it was here she had come one warm May night with a French soldier, a tall man with eyes as blue as the sea. They had been dancing in Mercato Vecchio, and afterwards she brought him to the cellar where, with a smiling flourish, he spread his cape on the straw and began whispering to her in French, a melody so quick and light compared to Italian....

The blow against her back left her breathless as she fell forward, hitting her head against the stone wall, and she felt her legs bend and go limp under her.

Then she was lying on the floor on her side, watching a dark brown stain spreading on the straw. It was the vinegar, the flask was broken because she had dropped it, because she fell, and now she would have to pick herself up with the thousand shards of light flashing on the rim of her vision, flashing smaller and smaller before giving way to blackness, like shutters closing.

sixteen

FLOATING TOWARD THE SURFACE, EYES opening, yellow moons spinning in darkness. Eyes closed, floating on visions and whispers. Was this death?

Eyes opening again, blue light, transparent yellow streamers, everything spinning. Close again, draw darkness down like a great dome.

Voices surround her, laughter, shouts, donkey hooves clacking on stone, a tendril of warm air on her brow, a breathing softness pressed against her.

Opening her eyes, she saw the face of an angel hovering over her, golden angel's hair, blue eyes, cheeks tinged with rose.

"Which angel are you?"

"Alessandro."

Now she saw that he was wingless, dressed in a linen shirt and grey doublet. "My head hurts," she moaned.

He stroked her forehead with cool fingertips. Beside her, Lorenzo stretched out to his full length and pressed his furry belly against her leg.

"There was an accident in the cellar. One of the vinegar barrels fell on you and knocked you down. Knocked you out.

Ottavio found you lying on the cellar floor. I was cleaning my brushes when he brought you up to the courtyard. I helped him carry you here."

"Why did I go to the cellar? Was it wine? Vinegar in the cellar, maybe it was vinegar."

Someone knocked lightly on the door. Alessandro opened it and said something in a low voice. He stepped back, and Ottavio came in, and she saw Ottavio's glance sweep over him appreciatively before he turned to her with a sharp, searching look.

"How do you feel?"

Her fingertips pressed tenderly against her temple and found swelling there, the hair stickily matted.

"Did I bleed? My head hurts, and my neck and shoulder. I cannot remember...."

"I came into the kitchen to speak to you, and the maids told me you had gone to the cellar. Then I proceeded outside to wait for you. As I approached the passageway, I heard a loud crash in the cellar, and I hurried downstairs, where I found you on the floor in a pool of vinegar."

Her skin tingled with chill.

"The Signora, knowing how conscientious you have always been, urges you to remain in bed until you are fully recovered, however long that may be. Clarice and Lucia will be responsible for the meals, under my supervision." His mouth fluctuated into a smile, and he clasped his hands together at chest height as if he were holding a secret in them.

Her mouth opened wordlessly, and her eyelids shuttered down before she could answer.

She slept.

Now the darkness was slashed with light, yellow light shimmering like bars of satin on the canvas sheet. Imaginary satin, which was the only kind she would ever have. Just once, if she could slip into a bed with French linen sheets and a satin coverlet, and great wings of white summer curtains floating above her....

A church bell rang nearby, and her throbbing head echoed

the sound. Lorenzo, curled against her thigh, raised his head, ears aimed toward the door like furred darts; a moment later she heard footsteps and a metallic clang outside the door. Then someone knocked softly.

She sat up, fingers groping behind her, and found the knife handle under the mattress.

"Come in."

Clarice stood in the doorway, holding a tray; the top of Lucia's head, a blonde crescent, was visible behind her shoulder.

"Come in and open the shutters, then you can stare at me."

With a quick glance at her, Clarice laid the tray on the table, while Lucia unbolted the shutters and swung them open.

The light hurt; she clamped her eyes shut, then opened them cautiously.

"We made broth for you," Lucia said. "With pasta."

"Butter?"

"We put butter in. And cheese."

"What day is it?"

"Tuesday." Clarice sat down, twisting a lock of hair in her fingers, and looked at her anxiously.

"I would like to wash first." Her voice sounded weak, hollowed out.

Lucia poured water into the bronze basin and carried it over to her. Then she wanted the mirror hanging on the wall, and the horsehair comb holder beside it. How loathsome she must have looked, with a bluish bump on her forehead, striped with lacerations, and the hair on the right side of her head hanging as stiffly as if it were carved of wood.

She ate the broth sitting up in bed while the two maids watched.

Clarice was chewing her lower lip.

"You did well," she said finally. "Use less salt next time."

"Do you want something else?" Lucia asked as a figure blocked the light from the doorway.

Then Veronica stepped into the room.

"My friend comes, Veronica! You two, back to the kitchen.

Leave the bread and the water. Ah, Veronica." She held out her arms to embrace her.

"I just heard this morning."

"How did the news travel?"

"From Antonia to Simone. He told me."

The two maids closed the door gently behind them. Veronica settled on the foot of the bed.

"What did he say?"

"A barrel had fallen on you in the cellar, and you were unconscious. An accident."

"Ottavio told Alessandro the same thing, but it was no accident. Someone pushed that barrel."

"Who pushed it?"

"That I cannot say. I saw no one, but when I add it to all the other things that have happened, I realize they are meant to intimidate me. A few weeks ago, I found a dead bird near the bed, and it was not Lorenzo's doing. There was a loop of wire or string, like the string from an instrument, around its neck."

Veronica leaned back, curling her upper lip in disgust.

"On Sunday, after I saw you in church, Laura and I visited Bella. When we came back to this room, someone had ransacked it."

"A thief?"

"No." She leaned forward, whispering.

"Someone must have gone to Bella's room and found her necklace missing, the original one. They must suspect that I have it, and that I can prove that the necklace found beside Emilia's body was a copy."

"Now they are trying to crush you with vinegar barrels. Whoever it is."

Giuditta was silent.

"Do you know?"

"I suspect it is Antonia and Simone."

Veronica caught her breath. "Why?"

"During their last quarrel, it sounded as if Emilia was planning to wed her to someone else. Antonia could have stolen

Bella's necklace and given it to Simone to make a copy, and she could have put the original back afterwards. Simone, or both of them, could have hired Angelo to kill Emilia and drop the necklace."

She leaned back against the head board.

"I suspect, yet I have no proof."

Veronia crossed her legs, swinging one sandaled foot slowly. Her finely cut lips were slightly pursed.

"When is the trial?"

"The Signora found out it is in September. If I live that long. It is fortunate that I am the cook," she said, laughing, "so they cannot poison me. Clarice and Lucia are cooking until I recover. They brought me soup this morning."

"How was it?"

"Too spicy. They used too much salt."

Veronica's eyes widened.

"Do you think it was to hide something else?"

"No." Veronica moved closer and stroked her hand.

"The girls would not try to poison you."

"Some poisons take several hours...." Suddenly her mouth went dry.

Veronica's hand was warm, reassuring.

"Be calm, Giuditta, and let us make this arrangement, that as long as you are convalescing, you will eat only what I bring you."

"So you agree with me."

"Are we looking for five legs on a sheep? I think it will make you feel better. Safer." She stood up and moved toward the door.

"I will bring you something this evening."

Again she slept and awakened in the humid afternoon and found herself alive. Not poisoned. This was how the *signori* lived, sleeping late, having meals brought to them when they were ill. As compensation for the accident, for the treachery, she would allow herself a few more days of staying in bed and not working.

She had so little free time—during the day she was busy in the kitchen, and there were just those few hours, after the evening meal, before she went to bed, exhausted and too tired to think.

Now she would take the time. Start with the empty vinegar flask, which had been half full two days ago. Someone must have emptied it and waited for her to go down to the cellar. Or hired someone to wait for her there.

Beside her Lorenzo yawned, revealing his needle teeth; stretched; sat up and began licking his velvet belly. Soon he would hop lightly down from the bed and walk toward the door with his tail in an imperious curve and wait for her to open it. Then he would stand in the open doorway watching, smelling, surveying, sometimes for so long she impatiently nudged him along with her foot before he ventured into the passsageway.

Once she had been that way herself, and now she had to revive the old habit of suspicion and watchfulness if she wanted to survive until the trial. Or afterwards, for if Bella went free and the authorities sought the real murderer, she might still be in danger in Palazzo Novella.

She sat up and swung her legs over the edge of the bed in the stagnant, shuttered darkness. Slowly she crept over to the window and opened the shutters; the sky was a bright silvery grey, and the air felt moist, as if it carried rain.

Or sadness.

In the evening, he went to see her again. She was sitting up in bed with a bright rectangle of grey gleaming behind her, illuminating her right side, and her left side blending into the crumpled shadows of the bed.

The door swung closed as he came nearer and saw the fall of her loosened hair; her face seemed more pensive than he remembered. He moved one of the rush-bottomed chairs away from the table and set it beside the bed.

"How are you feeling today?"

She swept forked fingers through her hair.

"Comfortable, more or less."

"I cannot help myself, when I look at you I have to imagine how I would paint you. Half in shadow." He sat on the edge of the chair and touched a strand of her hair lightly with two fingers.

"The colors for your hair and eyes."

His fingers grazed her shoulder as he brought his hand back.

"Do you know your eyes are layered with gold? Like little brush strokes of gold."

"My mirror is an old one, cloudy. It tells me very little."

"I would use umber mixed with gold to paint them. And your skin—"

Someone tapped at the door. She looked beyond him to the door, as if she expected it to open, and lifted her chin slightly.

"Who is it?"

"Veronica."

The door opened, and a beautiful woman with a smooth ivory forehead and grey eyes walked in carrying a basket. She laid the basket on the table and turned to look at him, her fingers twined at her waist.

"Alessandro Ubaldini. This is Signorina Veronica da Faenza, my dearest friend."

"Giuditta, you lie in bed and receive visitors in your room like one of the *signori*. Are you growing fond of this life?"

"No, I am growing famished. What have you brought me?"

"Gnocchi in mushroom sauce. Veal, artichokes, bread, and a little cheese." Laying it out on a bright tin plate as she spoke. His mouth watered; he had not eaten since morning.

Giuditta pulled off an artichoke leaf and bit it.

He moved a few steps backward toward the door.

"No, stay," Giuditta said. "Can you not stay? There is more here than I can eat."

Another day went by. Veronica visited her twice, bringing food and companionship. On the fourth day, Antonia came to visit her; the heels of her platform shoes rapped impatiently into the room.

"Grandmother wants to know if you will be well enough to cook for our banquet." Her knuckles rested on her hips as she leaned slightly forward, waiting for an answer.

"Someone threw a barrel at me."

"Threw? Ottavio said it fell on you. And why would anyone want to hurt you?"

Giuditta crossed her arms and stared at the doorway.

"What does that mean?"

"It means the Signora can hire other cooks for the banquet. There are many excellent ones in the city."

"Grandmother will not be pleased," she said, elongating the word, "by the extra expense."

"The Signora rules her sons and her husband by the threat of her displeasure, but she does not rule her cook that way."

"I will tell Grandmother what you said."

Giuditta laughed. "Do you see me cowering?"

Antonia's lower lip jutted out and her heavy brows drew together; then she turned and walked away, slamming the door behind her.

But that evening she told Veronica she would go back to work the next day. They were sitting at the small table in her room, with a single candle and a dish of grapes between them. Beyond the open windows, rectangles of sky shimmered like shot silk.

"Antonia asked if I would be well enough to cook for the banquet, and I became cross and said the Signora could hire another cook."

Veronica wrinkled her nose.

"I know. When I imagined a lot of strange cooks and helpers in my kitchen, I decided to do it myself." She plucked a grape off the bunch and ate it.

"During those four days I kept thinking about Angelo. He is the only link to the real murderer."

Veronica rested her forehead on one hand and refilled her wine glass.

"You are not afraid of him?"

"I am. But I think I must, we must, watch him closely when there is opportunity. He will be playing at the banquet."

"You will be in the kitchen." She flexed her hand, two fingers resting on her lips.

"I could help with the serving.... A pair of hands, a pair of watchful eyes. I can tell my Signora you asked me to help."

"I need your watchful eyes," Giuditta said.

A short time later, she sat on the window ledge and watched her friend move through the shadowed street. The echo of Veronica's footsteps continued for some time after she vanished into the darkness.

seventeen

CARLO EXTENDED HIS PUDGY HANDS above the bronze basin and rubbed them together under the thin stream of fragrant rosewater. With a graceful flourish, a serving woman offered him an embroidered towel. He wiped his hands and let his end of the towel drop— the other end clung to her shoulder—and as she raised her head and looked at him, his breath jammed in his chest because her face was so lovely, as serene as one of Fra Lippi's Madonnas.

She held the basin out to Antonia, sitting beside him, and he continued gazing at her high rounded brow, her thoughtful grey eyes and the soft bow of her mouth until she moved on, past the four musicians, and disappeared into the servants' dining room.

He was delighted with his place at the table between Caterina and Antonia—delighted because the silver wine fountain stood so near, and he loved to watch the red wine arching from its silver masks onto the rim and then past the small gilded putti into the great silver basin at the bottom.

In addition, he was close enough to hold his silver goblet under the curving wine and refill it himself, and he had done so several times during the first two courses.

He glanced at Antonia, who was making gestures at some cousins sitting across the courtyard with Domenico and Laura. They were flanked by a number of Alberti relatives—after the wedding he would have to remember all the new names and faces he had forgotten since earlier in the evening.

One of the servants began lighting the wall sconces in the arcade, while others arrived with new serving dishes—leeks in almond sauce, tortelloni, stuffed fennel.

He pricked his fork into one of the plump yellow tortelloni and shoved it into his mouth, and his eyes closed in delight as he chewed. Compliments to Giuditta tomorrow.

Now three of the musicians took up their instruments—vielle, lute and flute—and began playing a familiar melody that was nearly obliterated by the querulous drone of Enrico's voice. Enrico had not stopped talking since the banquet began, one monologue after the other—right now it was old Cosimo d' Medici—and it brought back memories of his youth, his acute embarrassment when Enrico had carried on past the point when anyone even pretended to listen.

Garrulitas. Both of his parents had it: when Enrico paused for breath, or to eat, Caterina would take over with a long commentary that had no relation to Enrico's remarks. All these lengthy chronicles night after night at the dinner table, yet not a single one was as entertaining as anything in Boccaccio.

Afterwards, lying on the bed in their apartment, their fingers entwined, he and Emilia used to laugh at them. Dear Emilia, who always gave him her rapt, worshipful attention and never accused him of being long-winded.

He leaned back in his chair and belched discreetly into his napkin. His eyelids drooped, he drowsed for a moment, then he felt Antonia pinching his arm, and he jerked himself upright. She passed the silver serving dish to him, and he saw that it was sliced duck breast in balsamic sauce, and his mouth watered again.

Veronica was leaving with the Albertis. In the kitchen, she clasped Giuditta's damp hand.

"You must be exhausted. Will I see you in church tomorrow?"

"If I sleep late, you will not see me in church."

Veronica leaned toward her and kissed her on the cheek.

"I saw nothing exceptional," she whispered, releasing Giuditta's hand.

"Perhaps later. Look for me here."

The servants were still carrying the dishes in from the courtyard; the kitchen floor was slippery with spilled food, it would have to be scrubbed tomorrow, and they might not finish washing all the dishes tonight unless the kitchen maids stayed up very late. Right now, they were giggling over the wash tubs as if they could stay up until dawn.

Two other servants brought the soiled tableclothes in and dropped them in the corner to wait for the laundress, who came on Monday. For a moment, she imagined herself dropping onto the soft pile of linen and falling asleep right there, but she wanted to ask Ottavio something. Then she would go up to her room and sleep.

He had no doubt that Emilia would be furious if she could see him lying on top of the green damask coverlet—it was new, purchased only a few years ago for the new four-poster bed—and every night, when Emilia was still alive, the servant had folded the coverlet neatly at the foot of the bed before anyone could lie down.

And now he was stretched out over the central panel of deep violet brocade, feeling as if he might spurt some part of the evening's three courses over the magnificent fabric.

Only a few moments ago he had tottered into the bedchamber and allowed his man servant to remove his doublet and shoes, but not his chemise, he was too tired to put up with that.

"Just leave the candle and go," he said, slurring his words.

Darkness covered the room except for a dart of blinking candlelight and the soft gleam of the white summer curtains tied against the bedposts.

He closed his eyes and smiled at the wonderful softness—three feather mattresses, a quilt and the silk coverlet—fitting itself to the contours of his back and hips.

In a moment he would float into sleep, he was hovering on the cusp of it, hearing unknown voices.... One sharp voice jabbed him awake now, repeating something she had told him the week before she died.

What was it?

Because he was only half listening to her, he had barely caught it.

"You will thank me for what I have done today," she said, but he did not ask her what she meant.

So he would never know.

At midnight, Clarice and Lucia were drying the last of the plate and cutlery.

Giuditta picked up Lorenzo, waited for him to adjust himself comfortably along her right arm, then took a candle and carried both through the courtyard and up the front staircase to the *piano nobile*.

Lorenzo unfurled his legs and jumped down, weaving before her with sinuous grace. But at the dark passageway leading to the two rooms, hers and Ottavio's, he froze, then crouched low to the ground, his black tail switching slowly back and forth.

The candle flame shuddered.

eighteen

CAUGHT IN THE PULSING WEDGE OF yellow light, a pair of high leather boots stepped toward her out of the shadows. She moved back toward the staircase, raising the candle until its light glided along the edge of the painted lute case.

"My compliments on the banquet," Angelo said.

She lifted the candle until the light quivered on his face, and his narrow lizard's eyes blinked.

"The duck breast was particularly praiseworthy."

"Did you hide in the shadows to tell me that?"

He offered a mocking little bow.

"I have a message for you." He moved back toward the passageway as if he expected to go into her room.

"Not here," she said. "If you want to speak with me, come down to the kitchen." If the maids were still there, she would not be alone with him; but if she were alone with him, the kitchen had three doors instead of the one in her room.

And she knew where the knives were kept.

The kitchen was deserted: the only light came from her flaring candle and a small oil lamp suspended above the fireplace.

Did she need any more light to talk to him, to look at his ugly face?

Yes. The better to watch him.

She lit two more candles and set them in the center of one of the tables, then sat down with her back to the garden door. He laid the lute case tenderly on the table and squatted on a stool facing her.

"Your room is a fine one for a servant, on the *piano nobile*. You are well treated here."

"I have always appreciated that."

"If you would continue to be appreciated," his glance slid away from her, "it is suggested that you abandon your interest in a particular situation involving this family."

"Who made this suggestion?"

"Someone who is concerned about your well being." He leaned back, stroking his long upper lip with his fingertips.

"I can see that she pays you well. A new beaver hat, new doublet and hose. Or was it two new doublets?"

He snorted and pressed one hand flat on the table. The red jewel in the center of his ring radiated thin flashes of light.

"Jewels as well."

"You cannot trick me."

"Into what?"

"Did you understand the message?"

Giuditta yawned. "Does she want a reply?"

He stared at her, smirking. He was enjoying his secret, his little taste of power. If she could simply shake him hard enough for the name to come tumbling out of his mouth.

As if anything could ever be so easy.

Something scurried across the floor.

"You can leave now," she said. "Take one of the candles for yourself."

She led him through Ottavio's office to the side door.

"Is this the lover's entrance?" he said with a snickering laugh.

She unbolted the door and held it open for him with one stiff arm. The feather of his new hat brushed her forehead as he

moved past her, then she pulled the door closed after him and bolted it.

She climbed up the back stairway, dragging shadow after her like a long cape, and moved slowly along the passageway to her room. Lorenzo brushed against her ankle as she unlocked the door, then she lifted the candle high and watched him glide silently into the room ahead of her.

After she locked the door, she unwound her hair and tumbled onto the bed, her arms curved above her head.

Lorenzo landed beside her, purring and circling, and finally lay down next to her right armpit. She brought her arm down and rested her hand on his rib cage, feeling its steady rise and fall.

Which little alleyway might lead to the name? Would flattery entice the name out of him?

"But he would know I was being mendacious," she said drowsily.

Lorenzo chirruped softly and listened until her breathing told him she was asleep.

nineteen

HER HEARING WAS FIRST TO AWAKEN AS thin slices of morning penetrated the gauzy darkness of her shuttered room, pulling her into wakefulness. Was it late? She late? No, listen. Early. Still early. Sunday quiet. Sleep again.

She turned on her side and threw off the sheet. Lorenzo whined and scrambled onto the floor. She watched him take a curving stretch, then jump onto the table and begin grooming himself.

He turned his head and looked at her expectantly.

Yawning, she swung her feet onto the floor, ambled over to the window and pulled back the shutters. Once again, the luminous summer sky had fitted itself perfectly around the red and white dome of the cathedral.

Lorenzo jumped onto the deep stone sill and bowed his head, pressing it against her stomach. It was always so simple for him, running away from danger, fighting when there was no other choice. After last night's warning, they expected her to run away like a frightened cat. And if she did not run, what could they do to keep her away from the trial?

Murder would be the most effective.

To appease them, she need only promise her silence while Bella was tried; and if Bella was found guilty and put to death, her continued silence forever.

"Mother of God, I cannot do that!"

Lorenzo twisted around and looked up at her.

"Yes, I am angry, but not at you. Not at you." She began stroking him under his chin. "The injustice of it...." Lorenzo lifted his chin higher and looked at her with an enraptured gaze.

When she went downstairs, the tables were gone and the courtyard was empty beneath the soft silver canopy of the sky. Pigeons waddled over the stones bobbing for crumbs.

At the foot of the stairway, she discovered a souvenir, one of the small sugar paste Cupids that had decorated the tables. She picked it up—the wings were broken off—and carried it into the kitchen, where she found Clarice and Lucia washing the dishes from the morning meal. Clarice looked up at her with shadow-rimmed eyes and smiled wanly.

Part of a melon lay on the table nearest her, its sweet flesh damply glowing; she cut thin slices, laid them on a plate and went outside to sit in front of Alessandro's fresco.

An earsplitting scream made her jump, and the plate jittered but did not drop. She heard running footsteps, then the groom bolted out of the passageway and streaked by her, a veil trailing from his hand.

A moment later, Antonia's maid came panting after him, her shrieks punctuated with laughter as she chased him around the arcade and back to the passageway—the floating veil brushed Caterina's stony visage as the boy ran past.

The chase would end in the warm hay of the stable, a few hours stolen until the *signori* returned.

She licked the melon juice off her fingers and turned to study the fresco. A beautiful garden blossomed on the wall, a valence of leaves stretching across the top, then parting in the middle like an arched window to reveal a soft brown and green

landscape. The crowns of the trees curved in green and yellow mounds, dented with shadow, and as she moved closer she could see that each leaf was a variation on tones of green and yellow. How he must have loved each one to paint it so carefully! And the serpent, with Emilia's thin, bitter face, wreathed in the sleek green apple leaves. Her glance moved back to the faces of Adam and Eve as if pulled by an invisible thread, and now she saw something in their eyes and gaping, speechless mouths that invaded her heart with a deep wordless ache.

Her gaze followed the curve of Eve's shoulder to the arm shielding her breasts, then the other arm, outstretched, with its splayed white fingers, and down the legs and naked feet treading on a carpet of forget-me-nots and narcissi, hyacinths, gladioli and anemones.

There were no blank areas anywhere—the fresco was finished. Finished since Friday, when she was too busy to notice.

And he had not come to say goodbye.

She sat motionless, staring at the courtyard stones; her body felt heavy, marble-limbed. Maybe she would go into the garden and lie down under a tree all afternoon and let the leaves drift over her.

Or back to her room, back to bed and not see or speak to anyone.

"Giuditta?" Veronica's buoyant step brought her quickly across the courtyard. Her hair curled damply against her temples, and a blush of pink lay along her fine cheekbones.

"I missed you this morning." She looked at Giuditta, and a small vertical crease deepened near one eyebrow.

"What is it?"

"A mood." She stood up holding the slick plate.

"I am holding back my soul with my teeth."

At midday, they crossed the Ponte Vecchio to Oltrarno and strolled toward Borgo San Jacopo, where they eventually came to a tavern in the first floor of a massive stone tower. The image of a white boar dangled on a wooden sign above the door. Inside

the tavern—it was not busy at this hour—they seated themselves in a small alcove with a good view of the room.

The hostess, a tall, angular woman with protruding teeth, brought cups of wine and a small pitcher of water to their table. Giuditta drank briefly, then clasped the cup in her palms.

"Last night, when I came up to my room, Angelo was waiting for me. As a messenger." She glanced at the ceiling for a moment.

"I was told I must abandon my interest in a particular situation...."

"And if you do so, will you be safe?"

"I made no promise, but I think I must remain quiet until the trial to make them think I have lost interest." She took a long swallow and wiped her mouth with a forefinger.

"Even if I must leave the palazzo and go somewhere else, nothing will prevent me from appearing at the trial with Signora Bella's necklace."

Loud voices in the passageway made the two women look up as a group of young men swaggered into the room. They glanced around the room with self-conscious hauteur, swung their sleekly hosed legs over the pine benches and shouted for the hostess.

The last to sit down, a young man with curly brown hair and a prominent chin, glanced toward the two women and took a deep breath which swelled out his blue and gold doublet, then turned his back toward them so they might admire the fine turn of his calf as he swung his leg over the end of the bench.

Veronica looked down at the scarred table and shook her head.

"Young men, young men."

"I fear that the one I desire has escaped."

"Alessandro? The one I met in your room?"

"My appetite for him...."

Veronica laughed, a deep easy chuckle. The young dandy looked at them over his shoulder.

"You know me, you know I have appetites. This morning I

discovered that his painting was finished. He is gone, and I do not where to find him or even what quarter he lives in." She leaned back against the wall of the alcove, tapping her fingers lightly on the table.

Veronica leaned back too, and a companionable silence settled between them.

"You could ask the Signora where to find him."

"The Signora? On what pretext?"

Veronica sighed. Her gaze roamed over the white vaulted ceiling.

"Shall we order some of the good chestnut cake they make here?" she said finally.

"We should. That way we can satisfy at least one of my appetites."

Now it was Sunday again, two Sundays gone without visitors, but they might come today, Laura and Giuditta, although how she must look, unwashed, uncombed, the dress stained, and the stench in the cell. She would remember that the rest of her life, if she lived, if they did not put her to death for Emilia's murder.

The murderer still walking free.

Someone in the family.

Antonia?

A bitter thought.

Who else then?

twenty

O N MONDAY, THE CROWDS IN MERCATO Vecchio made Taddeo's throat contract so tightly he was afraid his voice would come out in a ridiculous squeak if he had to talk to anyone. It took all of his concentration to walk without bumping into anyone, and this made him feel more awkward than usual. Like the farm dogs, who seemed like ordinary dogs outside but grew so much bigger when he brought them inside the farmhouse, where they stretched out in front of the hearth, their sides pumping up and down, tails twitching with gratitude.

He wiggled his back under the basket of leeks and looked around for a place to lay it down so he could begin selling. Those who came regularly to the market had covered stalls or trestle tables, but he and his brothers rarely had any surplus beyond their own needs. It was pure luck when there was more, and it occurred to him to use the abundance of leeks as an excuse to come into the city and satisfy a secret yearning.

He wanted to look at the women.

Standing still as he was now, although he did not have to worry about bumping into people, he was still overwhelmed by

their profusion, and the stalls with their piled vegetables, and people shouting, and men in fine livery riding through on horseback, and barbers cutting hair outside their shops, and the men huddled around their dice games, and the beggars with their bowls....

He started forward again, past the bloody odors from the butchers' stalls—the strings of sausages made his mouth water—and the tables mounded with glowing summer fruit, stopping to stare at a woman whose skin had the ripened glow of her basket of pears. Then he trudged on until he reached the last table in that row. Wriggling his arms free of the straps, he rested the mouth of the basket on the ground, where the leeks spilled out green and white. When he straightened up, he saw a woman behind the table looking at him. She was a stout old peasant with sunburned cheeks and white hair pulled back into a tight knob. She reminded him of his late grandmother, Gemma, and he nodded at her.

She nodded back—she had several teeth—and asked where he was from. Then she turned to help a customer, and he began watching the women, some as delicate as little birds, others tall and broad shouldered, like the one who was standing now before the old woman's pink and white turnips. He saw only a crown of dark red hair until she looked up and spoke to the woman, and he recognized the squarish shape of her face, the broad cheekbones, the strong line of her chin. The skin of her throat glistened with sweat as she turned away to lay the turnips in the basket of the young girl who accompanied her.

"Who is that?' he asked the old woman.

She crossed her arms under her bosom, and this gave him hope, it was the way his mother stood when she gossiped with other country women.

"She is the cook for the Novella family, you see, Palazzo Novella. The silk merchants." She leaned toward him, lowering her voice.

"People still talk about the death of that woman two months ago.... You have not heard? One of the women was murdered, a

daughter-in-law, and the other daughter-in-law was arrested and taken to prison."

She smiled at him, soft webs of wrinkles gathering around her mouth. He felt his jaw loosen, and a small croak of astonishment flew out of his mouth.

"Some say it was a false arrest, and the real murderer still has his liberty."

He turned away from the woman, scanning the direction the cook had gone, but he could not isolate her among the crowd. He lurched into the aisle without a word, leaving his basket of leeks; how could he look everywhere at once for her in this crowd? Had she started back toward the palazzo already? Should he go there and hope to catch up with her?

At the moment, he was trapped behind a slow-moving litter—from time to time a dainty bejewelled hand emerged from the curtains—and he had to wait until it reached the end of the aisle before he could move into one of the side streets leading away from the square.

Here the smells of foreign spices were all unknown to him, and he wanted to stop at each shop and inhale, but he tramped onward, looking from side to side as he went.

Suddenly he saw her a few yards ahead taking a small bag from a spice seller and dropping it into her apron pocket. A few long strides brought him beside her just as she turned away from the shop; he skittered around in front of her and planted himself like an oak, sweeping his hat off and crushing it against his chest.

"Pardon me, Signorina. Are you the cook of the Novella family?"

She frowned, scanning his face.

"Who are you? Haven't I seen you before? Where was it?"

"I cannot say where—"

"In the palazzo. Yes, you were talking to Emilia."

"Is that the lady who was killed by her sister-in-law?"

"Who are you?" she demanded, grabbing his arm. "Where are you from?"

"Ta-addeo Gubbio," he stammered. "Gemma's grandson."

He waited for her to loosen her grip, his heart banging with excitement and fear. Then he shoved his hat back on, jerked his arm loose, and loped away.

Her voice followed him, she was running behind him.

"I saw you talking to Emilia. What did you tell her?"

He tried to steer himself between two women, who abruptly moved together so he had to stop. She was beside him now, the color high in her cheeks.

"Tell me what you told her!"

"No," he wailed, "I cannot. Leave me alone." He turned and clasped her hand, his words coming in frightened spurts.

"I told her something because she bribed me. I told her she must keep it secret. Now she is dead, and I fear for my own life."

He tottered backwards a few steps, then turned and fled toward the square.

Watching his dusty black hat vanish, she felt something ease around her heart; now all her old suspicions about Antonia and Simone could be discarded because something else, something Emilia knew, had led to her death.

And he had known it first, this peasant Taddeo, grandson of Gemma. Something so vile that now he feared for his life.

"Clarice, Lucia. Come now."

Gemma. The name was familiar; she had worked at the palazzo long ago and Filomena used to speak of her even after she left.

If she found Gemma, she could speak to Taddeo again.

But to find Gemma, she would have to visit Filomena at her nephew's farm.

If she were still alive.

And if she were alive, would her mind and memory still be clear and vigorous?

twenty-one

AFTER THE PLUMP, BLUSHING TURNIPS were sliced and laid in rows in a buttered dish, and Clarice and Lucia had begun shaping the ground beef, bacon, coriander and rosemary into meatballs, Giuditta went outside, past the terrace, to a small stone bench under one of the oak trees and sat gazing at the grass.

She had often heard that the sight of green grass was soothing to the mind, but this was easy to forget in a city of terra cotta, dun and umber. Easy to forget how many shades of green there were, more than she could ever name—the soft green of the oak leaves, the yellowing green of the summer grass, the dark tone of the hedges, the blue-green of the cypresses.

A leaf detached itself and scrolled slowly downward onto the grass. Behind her the fallen leaves crackled, and she looked over her shoulder to see Alessandro coming around the corner of the terrace. He was wearing a dark green doublet and a small cap of the same color, his hair rippling in flaxen swirls from beneath the cap.

He stopped before her under the canopy of oak leaves, and as she looked up at his shapely mouth, she wondered what he would taste like if she kissed him.

She rubbed her palm over the empty place beside her, and he sat down with his knee rubbing against hers. She pressed back firmly.

"What do you think of the fresco?"

No one had ever asked her about a painting, no one wanted to know what she thought of Botticelli or Ghirlandaio. It was a question for educated men like Signor Enrico or Signor Domenico. Now her ignorance would be exposed, naked as Eve.

"I know so little of these things, only what I have seen in the churches, but it seems to me no one would ever become tired of looking at it. The beauty of the garden and of the figures surpasses Nature."

He smiled at her, and one hand moved and rested on her clasped hands.

"What did Signora Caterina say? Was she pleased?"

"She paid me the sum we had agreed upon but she made no comment on the work, as if she had not even looked at it."

Giuditta shruggged. "She says nothing about my cooking day after day, although guests always praise it. That is her way."

"I wish she were more appreciative, but I will not complain. Two advantages have come to me from this commission. With the final payment from the Signora, I was able to rent a studio for myself just outside Porta San Piero Gattolini. I am living there now, away from my family. And I have a commission from Simone Alberti to decorate the apartment he is preparing for himself and Signorina Antonia."

"I would like to see these rooms when they are finished."

"I hope you will become part of them by posing for one of the frescoes."

"Not like Eve!"

He leaned back, startled.

"No, no," he said gently. "A maiden with a basket of fruit on her head. Like Domenico's maiden in *The Life of St. John.*"

"Ah, the maiden bearing fruit and wine. The fabric of her dress...." She was distracted for a moment by Clarice and Lucia's voices in the herb garden.

"The way she carries herself is a likeness of you."

He was looking at her in that manner that was peculiar to him, as if he would inscribe her on his memory forever. She noticed again the way his upper lip hovered above the lower, disclosing the glint of small even teeth.

Footfalls crackled on the leaves, and she turned and saw Clarice with her mouth agape, her pale brown eyebrows drawn into a peak.

"What is it?'

"The trout you wanted us to stuff for dinner. Lorenzo found it...."

"Only Lorenzo. It is not important. We can have the little thrushes instead. Go back in and start cleaning them."

Clarice turned back toward the kitchen, and a moment later, Lorenzo strolled out of the herb garden and leapt onto the stone bench beside her. He yawned, and his nubby pink tongue swept his chin and the corners of his mouth.

"Your breath smells of trout," Giuditta said, "but I forgive you."

He rubbed his head against her arm.

"Giuditta."

Alessandro stood up, one hand resting on his hip, looking down at her.

"Could you come to my studio and pose for me?"

"I am free only on Sunday."

"This Sunday?"

"I am going to the country on Sunday. The following Sunday.... I go to mass at Santa Maria del Fiore, I can meet you afterwards."

"At the north door."

Suddenly he leaned forward and kissed her cheek. A bird began singing in the oak as he crossed the grass toward the terrace, a song of full-throated elation.

That evening, the family lingered at dinner—Simone Alberti was their only guest—delaying the servants' meal. The hour was late

by the time Giuditta left the kitchen and started up the back stairway to the *piano nobile*.

Darkness parted and fell away on either side of the candle's beam as she moved along the passageway, which was so narrow that two people could pass each other only by flattening themselves against the walls. The darkness faded to shadowed grey as the passageway angled left and joined the loggia, and here she paused, remembering how Angelo had waited for her two nights ago.

Slowly she entered the dark corridor leading to her room.

She set the candle down on the tiled floor and unlocked the door. Lifting the candle, she swirled its glowing disk around the room; she walked over to the table and put it down, then walked back and locked the door. She took off her dress and threw it over the back of a chair, slipped off her shoes and hose and let her feet spread out against the warm brick tile as she moved over to the windows and pulled back the shutters. Cool air, fragrant with rain, glided into the room as she settled herself in the window bay and looked out at the starless sky rising behind Il Duomo.

A gust of wind rattled the shutters, and some drops spattered her face. Thunder rumbled beyond the hills. The candle flame dipped, laid flat by the wind, and she closed the shutters just as the rain began to batter them.

Now it was time to combine everything she knew, like ingredients in a recipe, into a truth that would save Bella.

Beginning with Taddeo, that awkward, sallow-faced being who had told Emilia the secret.

The secret of someone who entered Bella's room to steal the necklace and have it copied.

Someone who left the fake necklace beside Emilia's body or hired Angelo to leave it there.

Someone who had the key to her room and had left the strangled bird as warning.

Someone who found the original necklace missing from Bella's room and came to her room to find it.

Thunder broke overhead, like the sound of barrels falling. Shivering, she plucked a shawl off the wall peg and sat down on the bed, holding her elbows in her hands and listening for Ottavio beyond the wall they shared.

She had known his secret for years and never revealed it, he knew that. Was that the secret Emilia had pried out of Taddeo and threatened to expose? Not for money, Ottavio was not a rich man, but for the vicious satisfaction of it, and because she disapproved of men who loved other men.

Her heart hammered as she crept into bed and pulled up the sheet. She was prey, like one of Lorenzo's little limp mice or baby sparrows. There was no place in the palazzo where she could hide from Ottavio, he knew every corner and niche and secret passageway as well as she did, and he had a key to every room.

She closed her eyes, listening for Lorenzo's imperious meowing outside the door, which soon came. She padded across the room to let him in; whining loudly, he rubbed his rain-slick fur against her leg as she locked the door again.

"Shush. You should have come in earlier."

He shook himself, spraying drops on her bare feet, and followed her to bed, muttering to himself.

twenty-two

S HE HAD FORGOTTEN THAT SONGBIRDS and insects still sang in the roadside hedges; that a canopy of sweltering heat hovered over the fields of ripe grain; and that the combination of golden fields, purple vineyards and grey-green olive trees could be so beautiful. On some days, a mist veiled the landscape, softening the terraced hills and the spired cypresses, but today the sky gleamed a clear blue.

Even though the sun battered her straw hat, and dust clung to her damp skin, and her goatskin canteen was almost empty, the serene beauty of the countryside was soothing.

Now she came to an ancient oak whose shadow enclosed half the highway; just beyond it a cart track forked west toward the farm where Filomena lived with her nephew.

In the shadows under the oak, she saw two figures lying at the base of the trunk, and she looked away, smiling. A fine day for it.

She went past the tree and turned onto the narrow cart road, which was bounded by hedges on one side and a low stone wall on the other. The land rose gradually toward terraced fields, and farm buildings clustered within sight of the road as far as she could see.

Farther down the road, she saw the crown of a second oak and a grove of olive trees: the farm of Filomena's nephew lay a short way beyond.

The high crown of the oak waved at her as she went on, passing a vineyard, then following a sapling fence as it curved toward the old stone farmhouse where Filomena lived.

She stopped at the edge of the farmyard and took off her hat, wiping sweat from her brow with her finger. A red-hatted rooster strutted in front of her, and mosquitoes circled in the still air, which was pungent with the odor of animal dung.

She saw no one else in the yard; she looked toward the farmhouse and saw its open doorway gaping like a toothless mouth. On one side of the doorway, a little rose tree leaned in its clay pot; beside it, on a low bench, sat a small hunched figure dressed in black.

Giuditta took off her hat and moved tentatively toward the woman, whose hands curled stiffly in her lap. Small hands with short blunt fingers, capable hands as familiar as her own.

"Filomena?"

No response. She knelt in front of the old woman and saw that her eyes were closed. The heavy, seamed lids, the blunt nose, the ridge of muscle beneath the lower lip. She touched her hands and called her name again.

Filomena opened her eyes and stared at her as if she had never seen her before; then something began to glow like a candle in a faraway window, and she smiled toothlessly.

"Is it you, Giuditta? Why did you not come sooner?" Her voice was as strong as Giuditta remembered it, with its unique timbre that reminded her of old polished wood.

"I have no excuse. I think of you often, even though I am not with you."

"Child!" Filomena called. "Come here. I have a guest."

A slender girl of about twelve appeared in the doorway and stood resting one bare foot on top of the other.

"Take my guest inside to wash and give her something to drink."

The girl nodded, unsmiling.

"I will wait here for your news."

Inside the farmhouse, the girl offered a basin and towel shyly. Giuditta skimmed water-wet palms over her face slowly, again and again; she lifted her chin, splashed her neck, took hold of the towel's end and pressed it to her face.

Now the girl brought water and poured it into an earthenware cup. A sweet taste. She drank slowly as the girl watched.

"You have to sit next to her," the girl said, "or she cannot hear you."

On the bench, beside Filomena, she waited for the old woman to begin.

"How is the family?"

"Most are well, but Emilia has left it unexpectedly. She was murdered."

"Ha!" A throaty laugh escaped her.

"Bella was charged with the murder and imprisoned, but I know she is innocent. No one in the family except Laura will help me try to free her. Not even Domenico."

Filomena leaned back, her eyes narrowing.

"How can I help you, I am so old now, I cannot remember...."

"Do you know someone named Taddeo Gubbio? "

"Taddeo, I know Taddeo. He is Gemma's grandson. She was Caterina's old nurse. Gemma left when Caterina married and she came back to live with her son. She is gone now. Last year. The grandson is a tall man with sallow skin and a hawk nose."

"I met him near the market. He followed me to ask if I worked at Palazzo Novella, and I thought he looked familiar, then I remembered I had seen him talking to Emilia. He said Emilia had bribed him to tell her something, a secret she did not keep."

Filomena crossed her arms, nodding.

"He said he fears for his own life now."

"Emilia never could keep quiet about anything."

"But Taddeo...do you know where he lives? If I can talk to him and pull the secret out of him...."

Filomena wiped a little moisture from the side of her mouth.

"He lives on the next farm over with his brothers."

An hour later, she embraced Filomena tenderly, her throat constricting as she kissed the old woman's soft, furrowed cheek. Then she walked quickly across the yard and crossed the road.

Ahead of her, the cart track dipped and curved past a lake of bluish shadow beneath the oak. Framed by the outstretched branches and the cleft between the trunk and stone wall, the barley fields swayed under a gliding breeze. She loved this time of day, the soft tranquility of the land under the dense golden light: time stopped as if suspended on hummingbird wings, and all the past became present in a single moment.

But now was not the time to linger or be distracted. Now she had to find out what Taddeo knew.

While the rest of the family lay asleep in the heat of the afternoon, Taddeo wandered restlessly toward the roadway to sit under the oak tree.

He took off his hat and laid it on the wall.

He had not slept well the past few nights, and he was very tired. Snatches of sleep had been broken by long periods of wakefulness in which he relived the encounter with the cook so many times that now, when he saw her coming toward him on the roadway, it seemed he must be imagining her.

She stopped an arm's length away.

"Taddeo Gubbio, I am Giuditta da Forli, a friend of the unfortunate Signora Bella Novella, who has been falsely imprisoned."

His hands began to tremble, and he clasped them behind his back to hide his fear.

"I appeal to the kindness in your heart to help this poor soul's suffering."

His heart made a fearful leap toward his throat.

"You spoke to Emilia that day, the day I saw you, but you had come to see someone else. Who did you come to see?"

"No," he stammered. "No, I cannot." He grabbed his hat and moved a few steps away from her.

"What did you tell Emilia?"

"No more!" he shouted, and he turned and loped away from her across the roadway and through the dusty yard into the farmhouse.

She did not pursue him.

twenty-three

I T WAS NOT YET DAYLIGHT WHEN GIUDITTA
went down to the kitchen to begin baking the new loaves
for the family's morning meal. As the sun rose and shadows
fled to the corners of the room, as the oven heat and the aroma
of baking bread filled it, the servants arrived in twos and threes
to sit at the one of the long tables eating yesterday's bread and
asking for anything left over from the night before.

The personal servants came earliest and left first to wait in
the *anticamera* for the *signori* to awaken; the others—the garden-
ers and stable hands, those who scrubbed and dusted—arrived
later and were gone by half past seven.

Ottavio appeared at seven, solemn and alert in immaculate
black, greeting everyone quietly. A prickle of fear ran down her
spine this morning when she heard his voice, and she kept her
back turned to him as she slid the first loaves into the oven.

"Good morning, Giuditta."

She turned, wiping her hands on her apron. He smiled at
her, a slight upward tilt of closed lips. His mouth was secretive,
but his eyes were eloquent, full of feeling; she studied them,
looking for the enmity coiled in their depths. He waited for her

to speak, and when she remained silent, he raised one eyebrow questioningly. She shrugged and turned away.

She had seen no animosity in him.

She listened to him crossing the kitchen to his office, the door hinges creaking, his waning footsteps inside. He was never very far from her in his office next to the kitchen or his room next to hers, and her routine was well known to him—Mercato Vecchio or via Speziali when she left the palazzo, Il Duomo on Sunday.

He could easily find her if he wanted to.

She went over to the cupboard and took out two small jars, ground almonds and ground nutmeg.

"Clarice, you can grate zucchini for the frittata, and some Parmesan, then chop a little garlic."

In the next hour, mixing the zucchini with eggs and cream, arranging thin slices of melon on a platter, she forgot Ottavio; when the *signori* were seated in the *saletta*, she carried in the warm fritatta and served everyone, then stationed herself beside the doorway and waited.

The *signori* were arrayed on one side of the table, Caterina and Enrico in the middle, their sons beside them. Enrico sat stiffy upright, staring into space, perhaps monitoring the work-ings of his stomach, which was dyspeptic.

Caterina's crown of white hair reached only to his shoulder, and as she watched the Signora, Giuditta had the odd sensation of seeing her as a stranger might—only a tiny old woman with faded blue eyes and pale parchment skin—not one of the shrewdest and wealthiest merchants in Florence.

Enrico lifted a forkful of fritatta, and as his lips closed around it, Caterina said, "Enrico, that will kill you."

He ignored her, staring ahead as his jaws worked methodi-cally; Laura hid her face behind a napkin and giggled.

Caterina picked at her food; the two sons ate steadily with-out looking at anyone.

"That woman," Enrico said to no one in particular.

"Who?" Caterina asked.

"Carlo's wife. She was too loud. Always complaining about something."

Carlo continued eating, but Antonia's brows converged, and she scowled at her grandfather.

"What could we do?" Enrico continued with a shrug. "He was married to her."

Antonia whispered to her father, who grunted and stuffed a chunk of bread into his mouth.

"I never heard so much wailing in my life as when she gave birth. She was heard all over the quarter," Caterina said. "Not like the women in our family."

Domenico, leaning back in his chair, made a little ball of bread crumbs and rolled it around his plate.

Enrico belched and covered his mouth with his napkin.

Caterina nodded at Giuditta, and she went over to the table to begin clearing the plates. Laura remained seated, waiting for her.

"Come to my room," she whispered, "I have something to tell you."

An hour later, Giuditta pushed open the door to Laura's *anticamera* and went in; the room was empty except for a small bird in a wicker cage near the window.

"Signorina Laura?"

She passed through the portiere to the bedchamber, where sunlight sifted into the room from the unshuttered windows and creased the flowing canopy curtains with light.

No one was in the room. Giuditta took a step closer to Laura's dressing table, and her glance moved enviously over the silver nail scissors, the scented soap from Milan, the tiny glass jars of lemon balm and almond oil.

"Signorina Laura?"

A door flew open in the wall, and Laura walked out of the privy.

"A good place to hide, Signorina."

Laura went over to the nightstand and dipped her hands in the bronze basin.

"I used to hide there from my nursemaid and from Mother until they came to expect it." She bounced onto the bed and patted the space beside her.

"My clothes.... My apron is dirty, it will make the coverlet dirty."

"Grandmother found out the trial has been moved forward. Two weeks from next Monday, in the morning."

"So soon." Fear prodded her heart. "After the banquet Saturday I was given a message to abandon my involvement."

Laura's eyes widened. "Who?"

"Angelo."

"Are you in danger?"

"Who can say? Someone is displeased with me. If I have to hide somewhere before the trial, do not conclude that I have abandoned your mother."

"Where would you go?"

"I have friends who would shelter me."

She went over to the window and looked down at the smooth-shaven hedges enclosing the herb garden; the terrace and balustrade with its damaged Neptune; the great oak casting shadow over the poppy-starred grass; the bristling cypresses piercing the cloudless sky.

She closed her eyes for a moment, inhaling the fragrance of lemons rising from the terraces: once that had been her life, simple thoughts of lemons and garlic and rosemary. She turned and looked at Laura.

"When I first came here, younger than you are now, your mother intervened when Signora Caterina wanted me to leave, and I was able to keep my place here. I have not forgotten how much I am beholden to your mother, and I will not be frightened into abandoning her."

That night she lay awake behind her locked door, listening. A few times Lorenzo growled, and she heard footsteps by the door and reached behind the mattress for the filet knife, clutching it until the footsteps went away.

Taddeo, too, was still frightened; the secret he knew belonged to someone still living. But how would a such a peasant, so slow-witted and awkward, come to know it?

Unless it was Gemma's secret, which someone had paid her to keep. When she died, the keeping of it passed to Taddeo, until Emilia bribed him to reveal it.

If it were Gemma's secret, and she had left the palazzo shortly after the Signora was married, then the matter would have occurred either before or even a little after the marriage.

Was it connected in some way with the death of Rinaldo before his marriage into the Alberti family? And who would know, who would remember?

Simone's mother, Ginevra Alberti, would be old enough to remember if Veronica could be persuaded to ask her.

On Thursday evening, Veronica waited for her outside the palazzo, and they began walking slowly along via del Corso. The air was sweet and mild that evening, tinged with approaching autumn.

"I did not know how to bring it up," Veronica said, "so I began asking Signora Ginevra about Simone's wedding. We talked for a while about the two families, and finally I thought I should ask her before we went on to another subject."

A pair of squealing rats darted across the shadowy street just in front of them.

"Rinaldo Novella was a friend of her husband's uncle, Signor Bernardo."

"Does the Signor still live at Palazzo Alberti?"

"He came to the banquet…but you were in the kitchen all the time."

"He was Rinaldo's friend—"

"Yes, the family first knew him in that way. After a time, a marriage was arranged between Rinaldo and Signor Bernardo's sister, but Rinaldo became ill suddenly and died, all in one day. It was neither fever nor plague, and everyone said he was too young to have enemies."

"An enemy within," Giuditta muttered. "What else?'

"There were rumors. The coroner did an autopsy and found that the young man had been poisoned. No one was ever arrested."

They had reached Piazza Santa Elisabetta, and the grim tower where Bella was imprisoned.

"Someone knew. I think Gemma knew. And Taddeo knows now."

The two women stopped, and Giuditta stood looking up at the lightless windows of the Pagliazza for a moment before she turned away, shivering.

twenty-four

ALESSANDRO COULD NOT REMEMBER THE last time he had gone into Santa Maria del Fiore to look at the choirs by Donatello and della Robbia; it was sometime earlier in the year, and the feeling of humility and awe made his breath stop. And then to go outside and look at Ghiberti's panels and be astonished once again.

Today he had stayed outside, waiting for Giuditta, and now, as the great bronze doors opened, he began looking for her in the crowd. She saw him first and started toward him, and he noticed that her long russet braid was pinned up, exposing the lovely curves of her neck and shoulders. It would be a pleasure to draw those lines.

She followed him through the crowd, past the Baptistery and the Palazzo of the Archbishop. But as they passed under the great arch spanning the entrance to via de' Pecori, he remembered how shameful the street had become, with whores lurking in the doorways and alleys. One of the inns on the street, Osteria della Mala Cucina, was particularly notorious.

She moved closer to him and took his arm.

"Forgive me," he said. "It was stupid to come this way."

Two men stood in the middle of the street shouting at each other. Farther down, two whores in clattering platform heels were coming toward them; both women stared at him boldly, then passed by without saying anything.

They turned onto via dei Vecchietti, and she said, "It is a relief to be away from the palazzo for the day."

He looked at her questioningly.

"I meant that I do not feel safe there. The trial is only a week away, if someone wishes to silence me...."

His pulse throbbed with apprehension.

"Who is it?"

"I do not know who it is. Whoever it is sent Angelo with a message."

"What Angelo?"

"The music teacher. For years he has come every Wednesday to give lessons to Antonia and Laura. Someone hired him to kill Emilia because Emilia had found out that person's secret. That person copied Bella's necklace and dropped it—or Angelo dropped it—beside Emilia's body. I found the necklace, the original, in Bella's room, and it is with this I intend to free her. They know I have it, the murderer knows, he ransacked my room looking for it."

An old woman sitting in a doorway watched them with a stolid gaze as they passed.

"Then you must not go back there. Stay with me until the trial."

"I cannot. There is more to be discovered in order to free Signora Bella."

They passed by Mercato Vecchio, filled with worshippers from the four churches, and continued down via Calimala toward the Ponte Vecchio. She was silent as they walked, and he hoped she did not expect him to talk because he was always hesitant that way, he lacked the easy banter of other young men. That was what women liked, and they liked it when one sang to them or played the lute or wrote sonnets. But what would a sonnet be worth to her now, in this perilous time?

They stopped at the piazza in the middle of the bridge and looked south toward San Miniato. A string of damp pearls lay across her brow, another at her throat. He would offer her wine when they reached his room, and after they had refreshed themselves he would have her pose for him. At this moment she was still unknown to him, but he would explore her with his eyes and his drawing hand as if she were the New World, and he would come to know her more intimately than any sonnet-writer or ballad singer ever could.

Outside Porta San Piero Gattolini they turned onto a narrow country lane that climbed leisurely upward; a low stone wall separated it from a meadow of yellowing grass. At the bottom of the road stood a villa of tawny stone, surrounded by tall hedges and cypress.

He opened the side door, and she followed him up the cramped stairway to the second floor and along the windowless passageway to his room. The door swung open, and he made a little bow, gesturing her inside.

He had left the two windows unshuttered when he went to meet her, and the effect of brilliant summer light pouring through them as she came into the room was a splendid greeting, a flourish of trumpet and drums. He watched her amble across the room inquisitively, not that there was much to see beside his easel in the center of the room, angled to catch the light, and a trestle table beside it for his pigments, his brushes and palette.

Passing the table, she trailed her fingers along its edge, and when she reached the far wall she stopped beside the small, cloth-draped table where fruit clustered on a bronze tray beside a straw-girt wine flask.

"Thirsty?" He took two glasses from a shelf above the table, filled one from the bottle and handed it to her.

"Where do you eat?"

He poured a glass for himself.

"Not here. I buy bread on the way to Palazzo Alberti in the morning. I eat the evening meal in an inn."

She sipped the wine, moved her tongue slowly across her bottom lip.

"You will grow thin away from me."

When she was ready, he positioned her in the cascade of light beside the windows with her right arm angled to support the tray, her left hand carrying the wine, and one knee bent to give a beautiful flowing movement to the folds of the skirt.

But looking at her from the easel, he was still not satisfied, and he took the flask away to leave one hand free. Then he sketched her from the front and from the back. He drew the free hand with its pattern of raised veins and the thumb curving back from the first joint; he studied the convergence of muscle in her raised forearm and drew that.

He spent an hour drawing her face and its gently grave expression.

"Finished," he said finally. It was the first word he had spoken in three hours.

She pivoted around and carried the tray back to the table, then came back toward him, rubbing her shoulder. She stopped in front of him to look at the sketches spread out on the trestle table, one hand still cupping the curve of her shoulder.

"Is my mouth so wide?"

He laid his hand lightly over hers, and she drew her shoulder up, tilting her head to press her cheek against his hand.

"This is how I would draw yours," she said, running a fingertip over his upper lip, "two curves and a dip."

"Or this way." He wound his arm around her waist and pressed his mouth against hers as he guided her toward the narrow, unmade bed. They stopped with the back of her knees pressed against it; then she kissed him more forcefully as she untied his shirt and slipped her hand into the opening so her palm rested against his chest.

"Now it is my turn to look at you."

She eased his shirt off, and he watched her bemused smile as she gazed at him, while her fingertips traced a long vertical line from his throat to the arch of his rib cage.

She made a little purring sound in her throat as he pushed the straps of her dress off her shoulders.

There was no canopy to shelter the bed; he tossed the coverlet back and watched her step out of her dress. The chemise fell in a crumpled cloud beside it.

He sat on the edge of the bed, waiting for her.

She moved beside him and stroked his hair, entwining her fingers in its waves. She traced the line of his jaw and kissed him again. Her lips parted, and he explored the warm hollow of her mouth, gently circling, tasting.

He embraced her, pressing her gently down against the narrow mattress. He kissed the sunburnt skin of her neck and shoulders, heard the rhythm of her breathing becoming irregular.

Her hand glided toward his thigh, and her fingers closed around him.

He kissed her ravenously as she guided him inside her, then his eyes closed and he was engulfed by the great shuddering jolts of his own body.

Time stopped, and when it began to move again, he heard her sigh, and his eyes opened and beheld a pearly flush illuminating her face.

He lay on his side, her head resting on his outstretched arm.

He slept.

When he awakened, she was gone.

twenty-five

IT WAS PAST CURFEW BY THE TIME SHE reached the Ponte Vecchio and started across. The moon shone like veined marble in the deep blue of evening. Across the river, the palazzi and their ancient towers soared darkly against the sky, and candlelight cut warm rectangles in their facades. Torches flared beside the doorways.

The bridge was mantled in darkness, but she had a lantern Alessandro had given her, and the brilliance of the full moon. It was quiet on the bridge save for the patter of her own feet on the paving stones and the shush of the water hitting the piling. Passing the arches of the piazza, she saw streamers of moonlight on the water, and the beauty of it made her throat tighten. Everything seemed beautiful tonight—all her senses were open, unshuttered.

She felt too light-hearted to be afraid as she hastened along via Por Santa Maria, where no light shone, not even the oil lamps of a tabernacle, and only a narrow strip of moonlit sky appeared above the dark edges of the cornices.

The sky was still darkening, soft blackness descending from its dome as she reached the Piazza della Signoria; the tiny red

glow of her lantern bobbed like a firefly as she started toward the palazzo.

Now, from across the square, the echo of slow hoofbeats spilled out of the darkness. Police? If they took her for a whore and stopped her, a woman alone this late.... But the hoofbeats were going away from her as she entered via dei Gondi.

She crossed Piazza San Firenze to via del Proconsolo, walking down the middle of the street until she reached the palazzo. She set the lantern down, unlocked the side door and stepped into the store room. Here it was darker than outside, but so familiar that her feet recognized every step of the stairway to the *piano nobile*; she could not stop smiling as she climbed, remembering the rumpled delight of their lovemaking in Alessandro's unmade bed, clothes and blankets scattered all around it.

She reached the top of the stairs and paused: the lantern pitched a small cone of orange light along the back passageway, while to her right, the moon's luminosity reached down through the loggia into the mouth of the corridor that ran past Laura's room.

It was then she heard the stairway squeal behind her, and she flinched, swinging the lantern around toward the top of the stairs.

"Ottavio?"

The only answer was the sound of rapidly ascending footsteps.

The lantern light swayed, then laid down flat in its perforated iron cage as she bolted past Laura's room toward the loggia.

He gained the top of the stairs and started down the corridor.

She ran down the loggia toward her room, the lantern swinging wildly. But the door would be locked, she had left it locked in the morning. How quickly could she unlock it in the meagre glow of the lantern before he caught up with her?

Turning toward the front stairway, she looked back and saw a single darting flame and a dark hunched figure looming behind it. She left the lantern on the tiled floor and ran down the stairway, her footsteps echoing through the courtyard.

She dashed across the courtyard to the other stairway, raced to the top and from there looked back to see the candle bobbing below and hear his boots slapping against the courtyard stones.

Back through the loggia she fled toward the rooms over-looking the garden. The nearest door led to Carlo and Emilia's apartment: if that door were unlocked, she could hide in the *anticamera*, or in Emilia's room.

If it were closed, she would have to try to get back to Laura's room.

She slammed against the door with her outstretched palms, and it swung open; she pushed the door closed behind her and stood gulping air in the darkness.

She had not been in the *anticamera* very often, but she re-membered a doorway on her right which led to the dead woman's bedchamber. From his own chamber, beyond Emilia's, the rumble of Carlo's snoring carried through two sets of door hangings. And now a thin grey border of light was becoming visible around the doorway to Emilia's chamber.

Cautiously she began moving toward the center of the room, then froze as she heard footsteps pounding past the door. They stopped, then started back, and she plunged through the portiere just before he came through the outer door.

Carlo snuffled loudly and fell quiet, and in the silence she sensed the wary alertness of her pursuer's hearing. If only Carlo would start his racket again, she could risk moving. Not behind the bed curtains, there was someplace else, if she could find it in the dark....

Carlo's throbbing drone started again, and she began to move quietly toward the wall nearest the garden. Arms outstetched, fingers grazing rough plaster, she crept toward the left until the surface beneath her fingers began to feel warmer. Her hands fluttered at waist height, searching for the door handle; she tugged the door open, with a loud shriek of hinges, darted inside and pulled it closed.

She could hear him coming in the room now, footsteps cir-cling slowly, as if he did not know where he was.

Ottavio…. Ottavio would have known the room as well as she did, would have found the privy immediately.

But Angelo, unfamiliar with the room, might wait in the dark, listening for her until morning came.

twenty-six

CARLO LAY ON HIS BACK IN THE GREAT four-poster bed wondering if he could move. On the table beside the bed, the night light blinked feebly at him through the thin summer curtains. Still a few hours until daylight.

Of course he had no choice, his bladder was swollen, he could not ignore it and go back to sleep. He drew his legs up and swung them over the edge of the bed, belly following, and sat there for a moment blinking. His eyes felt sandy.

He stood up and reached for the night light, then shuffled stiff-kneed across the cool tile floor, through the portiere to Emilia's chamber and past her bed to the privy.

He set the candle down and saw that the door was slightly ajar—maybe he had left it that way last night. Swinging the door open, he stepped inside to relieve himself—he could still count on that easy flowing pleasure. He picked the light up and shambled back toward bed. He was still only half awake, that was good, he might be able to fall back asleep, maybe two hours or more before the servant came, better not to think even that far ahead, waking up the brain, too awake then, never get it back to sleep.

———

Giuditta slumped against the headboard and let her eyes close for just a moment. Not to lie down, she could not allow that, if she let herself rest even for a moment she might nod off and sleep past her usual rising time.

She had been trapped in the privy until just before dawn, when Angelo heard Carlo coming; she slipped out a moment later into the *anticamera* and waited until sunrise before she ventured outside and returned to her room.

Now she moved lethargically toward the window, opened the shutters and leaned out looking for the moon, her companion of last night—it had vanished, leaving the sky overcast. Cool air drifted into the room.

She stepped out of her Sunday dress, the pale green taffeta, and laid it away in her clothes chest. She poured cold water into the basin and splashed it on her skin—at least her skin would be awake—then she let her hair down and brushed it and pinned it up again.

A cart rattled past in the street, someone shouted, and all across the city, church bells proclaimed morning.

She pulled a linen dress on over her chemise and sat hunched on the edge of the bed, hands dangling between her knees. Six hours until she could steal a few hours sleep before the evening meal. She was already late this morning, but the two maids should have the wit to get the oven going and start the bread without her.

One thing certain. Never again, morning or evening, would she be found alone in the kitchen.

After the music lesson on Wednesday afternoon—the lesson had not gone well, Laura would not pay attention, and Antonia was seized by spasms of laughter—Angelo went down to the kitchen, where the spiky scent of cloves, oranges and vinegar greeted him. A loin of pork was roasting in the wide black mouth of the hearth; one of the kitchen maids stirred a pot suspended over the fire, another sat on a stool grinding something in a mortar.

Giuditta stood beside one of the work tables, one hand pressed against a cutting board, the other gripping a knife.

"Will someone have pity on me," he called, "and give me some water?"

Giuditta's blade thwacked a carrot into bright orange coins, and when she finally looked up, her glance drove into him like an iron bolt.

"Clarice, give him some water."

The maid pushed a damp lock of hair off her forehead with the back of her wrist and laid her stirring spoon aside. She took a pewter cup from the wall rack and poured water into it from an earthenware pitcher.

As water spilled into the cup, Angelo moved toward the work table and seated himself opposite Giuditta. Clarice set the cup and the pitcher before him and he drained it, dewy metal cool against his lips; he put the cup down and traced the wet rim with one fingertip.

Then he looked up at Giuditta.

The tip of her poised blade hovered above a tawny mushroom, then measured it into thin slices almost faster than his eyes could follow. He felt a slight tremor move through his shoulders. The rules had changed after he had seen her talking to Taddeo near the market, now his orders were to put her out of the way. If she had not eluded him Sunday, he would have done so, taken her to some black alley and left her there to be found the next morning.

She held half of an onion against the board, slicing it vertically with swift rapping sounds.

"You are very adept," he said, rising. "A virtuoso."

Her face stiffened as she reached for another onion.

"I like making clean slices and arranging them on a platter with parsley at the ends...."

She looked up at him, gesturing with the knife.

"Do you know what gives me the most pleasure? To carve up a big boar from the country." A gleam of teeth curved at him. "It gives me great pleasure."

The next evening, beneath a full moon rising like a splendidly engraved silver plate, Giuditta and Veronica strolled along via Cacciajoli toward Orsanmichele.

"I must ask you to help me again," Giuditta said. "My purpose now is to find out more about Rinaldo. If you could find a way to speak to Signor Bernardo—"

"As it happens, the opportunity has already presented itself. Signor Bernardo suffers from a digestive malady from time to time, and yesterday I brought him *biancomangiare* and sat with him while he ate. When he finished, he said, 'My niece tells me you asked about my old friend Rinaldo Novella.'

"Then he showed me a portrait medallion of the young Rinaldo, and as I looked at the portrait, Signor Bernardo began to speak of him. He had good manners and an agreeable disposition, but his mind was somewhat slower than average."

An old woman, shuffling, shawled in black, stepped out of a doorway in front of them.

"He was beset by sudden changes in mood, one day content, the next so morose he would not leave his bed. His father, Signor Filippo, doted on the boy, although those who knew him thought it would be calamitous if he ever inherited Filippo's silk business."

They had reached via dei Pittori, where artists displayed their paintings during the day, hoping for commissions.

"Is it not clear now?" Giuditta said. She halted in the middle of the street, and two young men standing on the corner turned and looked at her.

"Signor Enrico or Signora Caterina."

twenty–seven

B Y THE TIME SHE REACHED THE GREAT
oak tree, her parched tongue felt so swollen and le-
thargic that she stopped beneath the tree's undulating
canopy to unplug her goatskin canteen and drink avidly.

She had walked for more than an hour under a sodden sky
that pressed heavily against the earth. Now, as she started down
the cart track toward the Gubbio farm, doves murmured behind
the lichen-coated stone wall. A salamander darted out of the
wall, his bejewelled skin flashing, and stopped just in front of her.
With his flat head and narrow, enfolded eyes, he was, despite the
iridescent skin, chillingly ugly.

Like Angelo.

She waited until he sidled away under a hedge, then she
went on, quickening her pace. Only one day remained until
Bella's trial, one day to find Taddeo. If he could not be found, if
he refused to talk, then she had only the necklace with which to
save Bella.

Ahead she saw the crown of the second oak across the road
from the Gubbio farm. Glowing in its shade, then emerging and
coming toward her were two white cows. A peasant in a broad-

brimmed hat, like Taddeo's, walked between them, but he was shorter and older.

He greeted her as they passed; then she turned off the cart track onto a narrower pathway which curved around a vineyard and eventually broadened into the farmyard, where an ancient chestnut tree sheltered the farmhouse's tawny stone.

The barking of a dog grew more urgent as she approached; under the shade of the chestnut tree, some men and women and a number of children were seated around a trestle table enjoying their afternoon meal.

As she stepped into the yard, one man looked up from his plate and gestured to the dog, whose barking dwindled to a whine. She saw Taddeo sitting at one end of the table, mouth agape, bony fingers gripping the table's edge.

The dog trotted over and sniffed her skirt and her hand.

Another of the men stood up and gestured for her to come closer.

"I am Giuditta da Forli. I am the cook at Palazzo Novella, and I am a friend of Filomena Gambari."

"I am Vincenzo Gubbio, and these are my brothers and my wife. Please do us the favor of sharing our meal."

He was a young man, compactly built, with olive skin and thick black hair which tumbled like lamb's wool over his forehead and ears.

She seated herself across from Vincenzo, and one of the children scrambled to bring a basin and towel; another offered a plate and cup. Red wine gurgled from the mouth of a pitcher, and someone passed a tray of spit-roasted songbirds toward her.

She cut into one of the crisp-skinned little birds and took a bite. The others had stopped eating; she felt their curious gaze, a prickling of her skin.

More dishes were offered—grilled eel, sliced pork tongue, broad beans and stewed fennel. The men continued drinking; two of the smaller children slipped away from the table and ran dusty-footed across the yard.

Taddeo glanced at her furtively from the end of the table.

"More wine?" Vincenzo asked.

"A little."

Vincenzo leaned his elbows on the table and watched her as his wife and children began clearing the table. The other men rose and walked slowly past the front of the house to a stairway on the far side. But Taddeo remained.

"I have come to seek your help in saving an innocent soul from death. Signora Bella, the wife of Domenico Novella, has been imprisoned for the murder of her sister-in-law, even though she is innocent."

Vincenzo rubbed a finger across his teeth.

"Why do you come to us?"

"I saw your brother Taddeo speaking to Emilia a few days before she died. After she died, he accosted me near the market and asked if it was true that Emilia had been killed. When I confirmed this, he said she had bribed him to reveal a secret to her, but she had not kept it, and now he feared for his life."

"Ay, Taddeo! Greedy fool! Why did you not tell us this?"

Taddeo cringed, sucking his lower lip in.

"It was something my grandmother knew about the death of Signora Caterina's brother," Vincenzo said. "She knew who the poisoner was."

Lowering his head slightly, his eyebrows curved like dark wings, he looked up at her. His eyes were a clear, startling green.

"Emilia went to this person and must have threatened to expose him. This led to her death, and Bella was blamed for it."

"They killed her!" Taddeo shouted. "They will kill me if I go back." He began rocking back and forth, making a low keening sound.

Vincenzo was silent; he rested his brown calloused hands on the table and stared at them.

She waited.

After a time, he stood up and crossed the yard, lifting his knees high with each step, and went up the staircase to the second floor.

Taddeo had stopped rocking, but he was shivering.

An enormous ginger cat padded out of the ground floor of the house and stood blinking in the afternoon sunlight. It arched and stretched, fanning its claws in the dust.

Then Vincenzo was back; he sat down beside Taddeo and laid a folded piece of vellum on the table.

"Once a year for ten years, my brother has gone to Palazzo Novella to receive a payment. In the beginning, he collected on behalf of our grandmother, but after she died, it belonged to him.

"Our grandmother had a shelf in one of the kitchen cabinets where she kept herbs for healing. One of these was bella donna, which she used in small amounts to ease Signor Rinaldo's breathing sickness. On the morning of his death, Grandmother saw that the small jar of bella donna was full. Rinaldo was with his sister in the afternoon, and he died that evening. When Grandmother went to the cabinet again, she discovered that the jar was empty.

"Signora Caterina had made a tea from the leaves and persuaded her brother to drink it. That evening, Grandmother was able to remove the empty cup from Signora Caterina's room, and she kept the empty bella donna jar as well. After Rinaldo's funeral, she went to a notary and made a statement concerning Rinaldo's death."

His fingers tapped the document.

"As long as she lived, she received 100 florins a year from Signora Caterina for her silence. When she returned to the country, she had not the strength to make the journey to Florence once a year, so Taddeo went in her place."

Her stomach clenched; anger spurted through her heart.

"For this crime, she had one daughter-in-law murdered and would let the other one be hanged."

Vincenzo unfolded the document and handed it to her. Her eyes scanned the words without comprehension.

"None of us can read it either, but I know it is the right one."

She folded it up carefully and slipped it into her sleeve. In

the late afternoon light, the farmhouse stones glowed a soft umber. How tempting it was to remain here, with the sun's warmth caressing her back....

"Bella's trial is tomorrow. The Signora has tried to silence me, she has sent her assassin after me."

"Signorina, be careful. Do not take chances."

"If it pleases God, I will survive."

She started down the cart track with long, hurrying strides.

A flight of shrieking crows came gliding over the barley fields and one by one landed among the golden furrows.

She moved closer to the wall, and the crows flew off, swirling like black ash. Ahead of her, the cart track seemed deserted, but both the hedge and wall bordering it could conceal someone waiting for her. She hastened down the middle of the road, her glance swooping from side to side under the straw hat, her heart drumming as if it were playing in an ill-fated pageant.

Where the road joined the highway, she stopped and looked north to see who else might be traveling toward the city. No one on foot, but a pair of riders in the distance who seemed to be proceeding at a walk.

So it would be a little while before they caught up with her.

As she passed the first oak again, she swerved into the middle of the highway and continued there, listening to the hoofbeats behind her.

twenty-eight

I N THE DOORWAY OF A HOUSE FACING
Porta alla Croce, Angelo shifted from foot to foot, and his
agile fingers tapped the hilt of his dagger in its engraved
leather sheath. The arched doorway, cloaking him in a wedge of
dense shadow, gave him a direct view of everyone who came
through the gate.

He had followed Giuditta in the morning and watched her
leave through the gate. For hours he had been keenly watchful,
his gaze constantly sweeping the massive stone and brick city
walls and the blue hills beyond. Unless she decided to stay in the
country, she would return through the same gate, and when she
did, he would step quietly out of the doorway and follow her
along Borgo la Croce toward Borgo degli Albizzi. At the end of
the street, she would reach the side door of the palazzo—he
would have to catch her before she got that far or she could dis-
appear as she did last time after he let himself in and chased her
into Carlo's apartment.

And now he was standing on tired legs, waiting for her
again.

On the walk back beside a goldsmith and his assistant on their tired horses, an invisible hand kept squeezing Giuditta's stomach, and even now it would not let go. Her skin felt stifled, a veneer of dust coated her face, neck and arms; she could not stop thinking of the bronze ewer in her room, the cool strands of water splashing against her skin.

Now, just inside the gate, the two horsemen paused to wish her well before they continued across the square to Borgo la Croce.

She took off her hat and wiped the sweat off her forehead with the back of her wrist. A lock of hair looped down over one ear; she would let all of it down when she was back in her own room, brush the dust out. In a little while.

When she saw him step out of the doorway, she remained where she was and looked at him as if she had all the time in the world. He was hatless, his coarse black hair stringy with damp; she noted the breadth of his hunched shoulders, his rocking bowlegged gait, the way his hands curled at his sides.

His eyes were cold flakes of pale marble, not wavering from her face as he came toward her.

She darted away from him toward Borgo la Croce, a street of narrow houses filled with steeply angled shadows. The facades seemed to lean toward her as she ran, and only the swatch of darkening sky, intercut by the sharp angles of cornices and roof lines, assured her she was not running through a corridor.

Far ahead, where the street opened onto a large piazza, a faint grey haze stretched between the steep blocks of shadow. Windows gaped open to catch the evening's coolness, and cooking aromas seamed the air, but no one saw her as she ran past.

No one would help.

Now she saw, on her right, a tabernacle flame glittering on the portico of an ancient church, and she veered toward it. Refuge? Not if he followed her and cornered her there. Her leaping heartbeat drummed louder and louder in her ears, but not loud enough to submerge his thudding footsteps.

Ahead she saw the dark forms of the two horsemen encased

in the pallid luminescence from the piazza. When she caught up with them, she might be able to run across to another street she knew and lose him that way. Gauzy light was drifting into the end of the street as she drew closer, and she saw that the two horses were stopped, blocking the exit to the square.

Only a few houses away, with Angelo still scrambling behind her, she was just in time to see the goldsmith's horse lift his tail and dump a pile of steaming excrement in the middle of the street.

"Move!" she cried, and the assistant's horse jerked his head up and danced forward a few steps into the piazza. She ran into the square and kept on running until she reached the middle, where she glanced back at the same moment that Angelo's fine boots burrowed into the horse dung and he slid, arms flailing, to the edge of the piazza.

She turned away and ran toward a cramped little passageway; within the dusky light of its walls, she hurried toward a dark *volta* connecting two houses and reeled to a stop under its ponderous shadow. Sweat poured down her face and back, and her mouth was a dry cave; but reaching for the canteen, she remembered it had flown off her shoulder when she began to flee.

She moved slowly toward the north wall of the *volta* and pressed her back against its rough solidity. To her right loomed a massive stone tower with a few small houses leaning into it; the street lurched northward beyond it. To her left, the street was empty. If he came now, just now, she could sprint ahead like a frightened rabbit or stay in the shadow of the archway until he passed by.

But he would not pass by, he would find her there and shove her against the wall, his sudden knife blade pressed against her throat.

Her heartbeat surged in terrified waves. How long could she stay, waiting? Although the evening was beginning to lose color, and the rising moon was only a thin white paring, there was still time if she left now, she was not far from Borgo degli Albizzi.

She would walk quietly, close to the houses, until the street joined Borgo degli Albizzi at via Fiesolana.

Again she glanced left and saw nothing; she moved cautiously out of the archway and started up the street. Voices fluttered out of open windows, the cool sound of a flute floated on the air, and somewhere a child was crying.

Suddenly a door banged open in front of her, and two men tumbled out grappling with each other. Other men followed, surrounding them, filling the street. The odor of wine coursed through the open door of the tavern and lingered in the air.

She moved quickly toward one side of the street and flattened herself against the wall of a house, watching them—now he would come, she would turn and find him beside her, his ugly face swollen with malice.

She glanced backwards down the street. Still no one.

The spectators were moving apart silently—one of the men had fallen. The other stepped back, and someone took his arm and led him inside the tavern. One by one, the others followed, and when the street was empty, the beaten man staggered to his feet and began limping toward the piazza.

For a moment her aching legs refused to move, then she went on, past the tavern, until she reached the edge of the square and stood looking at a gnarled oak rising from a pool of deep blue shadow. The arch of its trunk and lower branches framed a row of houses at the opposite side, where an open doorway glimmered with light.

On the other side of the tree, at the corner of Borgo degli Albizzi, rose the massive silhouette of a new palazzo; soft yellow light pulsed in its windows. And now she was close—from here to via del Proconsolo, no more than a block, a street of empty lots and new palazzi under construction.

She stared intently at the opaque darkness under the oak but saw no one and heard nothing save the whispering of its leaves. Would he be there? Was he waiting somewhere on Borgo degli Albizzi or on via del Proconsolo, watching the side door? The only choice was to move out into the piazza and continue down the middle of Borgo degli Albizzi, away from concealing doorways and narrow alleyways.

Her heart jolted against her ribs as she crossed the square; behind a high stone wall, a dog began barking as she approached.

Glancing through one of the open windows of the old Palazzo Valori, she saw a blue wall warmed by candlelight. She looked down the street—empty except for the echoed beat of her sandals. But as she neared the corner of the palazzo and saw him run out from behind the wall, she felt strangely relieved: now there was no more waiting. Only fear, simple and familiar.

She sprang toward the other side of the street and began running like an animal, the urge to flee vanquishing any other thought. Look ahead, keep running, his ponderous footsteps thumping behind.

Her straw hat flew away, her hair came undone, loose strands slapped her neck.

Now she could see the lanceolate tops of the cypresses at the back of the garden, if she could reach the wall, she could run through the back gate—

She nearly stumbled over a mound of old wood and brick in the middle of the street but swerved around it just in time. Behind her she heard the slam of flesh against brick, an angry malediction.

She ran on beside the garden wall.

He was up again, running and bellowing curses.

She felt in her pocket for the key to the side door; there was no time to fumble with it in the dark, she would have to unlock it quickly, by memory, before he reached her.

The key shook in her fingers, hovering near the lock, as he shouted at her; then it went in, and she pushed open the door and lunged inside, slamming it closed.

Her mouth was dry as sand, her heart still racing as she trudged through Ottavio's office into the kitchen, dragging her exhaustion. Both oil lamps were lit, and the dying hearth fire splashed a crescent of reddish light on the floor.

A few candles flickered on the work tables, and by their light she saw stacks of unwashed dishes and cutlery, sticky frying pans, a rolling pin clotted with dough.

As she moved toward the table near the hearth, she heard voices coming from the half-open door to the *saletta*: Caterina, Carlo, then Laura.

She took a tin cup from the rim of the sink, turned on the tap and filled it with water. Drinking, she could think of nothing but the act itself, she became her own throat swallowing, the water dribbling onto her chin and hands. She filled another cup and drank it empty.

And now she would sit down and rest.

"Ottavio?"

The burly figure hesitated in the doorway of Ottavio's office, then rushed toward her with his dagger raised in his right hand.

Angelo's face, twisted with fury, the shaggy eyebrows drawn into a bestial ledge over his eyes, frightened her more than the knife. At the last moment, she stepped aside, and he hurtled forward into the brick oven. His fingers jerked open, and the knife flew onto the floor in front of the hearth.

She kicked the knife away, in back of her, as he turned toward her, half-crouching. His arms shot out to push her over; she stepped back, reaching for the table, and felt the grittiness of the dried dough, the cylindrical marble weight in her palm. She raised the rolling pin and struck him across the knees, and he crumpled, howling, to the floor.

Quickly she stooped to pick up the dagger and moved farther away from him. Snorting and panting, he staggered to his feet and gestured for the knife, his mouth wrenched into a deranged smile.

He charged at her, and she lost her balance and fell back against the table. Dishes leapt and clattered to the floor. Now she heard running footsteps in the *saletta* as he lunged at her, and she raised his dagger and slashed the filthy sleeve of his doublet.

Laura screamed.

Angelo backed away, holding his arm, his mouth stretched downward in a silent wail, and reeled toward the cupboards.

"Why are you fighting?" Caterina stepped down into the

kitchen carefully, with Laura, Antonia, Carlo, Ottavio and Lucia behind her.

"To save my life." Her breath was coming in aching gasps.

"He tried to kill me last week, but he failed, so he tried again today."

"To prevent you from going to the trial!" Laura shrieked. She rushed over to Giuditta and wrapped her arms around her.

Angelo moaned, gliding toward the floor. Ottavio moved lightly past Caterina and took the bloody knife from Giuditta's hand. Then he looked at Angelo slumped on the floor, legs splayed out, his mouth slack.

"He is filthy, and he smells of horse shit."

"Laura," Caterina said, "you are mistaken if you think anyone intends to exclude Giuditta from the trial."

"Someone has good reason to keep me away from the trial, Signora. I intend to bring the original necklace, not the copy that was dropped beside Emilia's body."

"What copy?" She drew herself up stiffly, her mottled hands clinging to each other.

"It was you who arranged to have the necklace copied so the copy could be left to incriminate Signora Bella. The police have the copy. I have the original."

Laura gasped and drew away from Giuditta.

"You were the one who paid this miserable wretch to assassinate Signora Emilia."

"Such a vile accusation!" The Signora was trembling. "I have never done anything to harm either of them."

"Tell us what cause you have to make such accusations," Carlo said.

"I have just returned from visiting the family of Gemma Gubbio, your mother's old nurse. I have been given a statement by Gemma Gubbio describing how Rinaldo Novella was poisoned by his sister with a tea made from bella donna leaves. Her grandson Taddeo knew this, and your wife bribed him to reveal the Signora's secret."

"Emilia threatened me! She said I must let Carlo take over

the business or the story about Rinaldo would come out." Her glance careened from Giuditta to Carlo.

"I did not kill her."

"You paid for her death, and let Signora Bella be imprisoned for it."

"Grandmother!" Laura began to cry in loud, hiccoughing gulps.

Carlo remained silent, staring at his mother.

"We will have to keep Angelo here until tomorrow so he can speak at the trial," Ottavio said.

Giuditta sat down on a bench. Lucia began picking the broken dishes off the floor.

Caterina's heels thudded grimly against the plank floor as she began pacing between the doorway to the *saletta* and the open garden door.

The fragrance of lemons drifted in from the garden.

Lucia carried the wash basin over to the sink and began filling it with water.

Caterina stopped in front of Carlo.

"The necklace makes no difference. I did not kill anyone. It is still my word against that of two servants."

Carlo let out a muffled howl, like an animal, and lunged at Caterina, his plump hands reaching for her throat. She staggered backwards, lost her balance and tumbled to the floor.

Carlo rushed over to her and knelt beside her, weeping, as his hands circled her throat.

"Father!" Antonia cried. "You are murdering her!"

"Signor Carlo!"

Carlo looked up as Ottavio moved toward him. Slowly his hands loosened, and he pulled them away and lurched to his feet.

"Father." Antonia laid her hand on his burgundy and gold sleeve.

"You are right, Antonia. It is the hangman's job."

epilogue

THE NEXT DAY, RELYING ON GIUDITTA'S testimony, which included Gemma's statement and the original necklace, the magistrate released Bella. She returned, haggard and weak, to Palazzo Novella.

Following the same testimony, the police arrested Angelo and charged him with the murder of Emilia.

Caterina banished Giuditta from Palazzo Novella, and she went to stay with Veronica at Palazzo Alberti, where Alessandro had begun decorating the new apartment.

Soderini interviewed Giuditta at length, and Caterina was subsequently arrested and imprisoned in the Pagliazza.

Angelo was convicted and sentenced to hang on the gallows outside the city gates.

Despite Enrico's petition to the Signoria for leniency, Caterina was sentenced to death and died on the same gallows a month later. Following her death, Enrico grew so confused and irresponsible he had to be confined to his apartment.

Carlo inherited his mother's portion of the business and bought Domenico's share. With his new capital, Domenico began a new business importing and selling antiquities.

Giuditta returned to Palazzo Novella as cook.

In June of the following summer, Antonia was married to Simone Alberti.

Alessandro's renown increased as a result of his work in Palazzo Alberti, and he became so sought after and so richly rewarded that he was able to establish his own workshop in Borgo San Jacopo.

He and Giuditta continued to enjoy each other's company.